Experimental Landscapes
in Watercolour

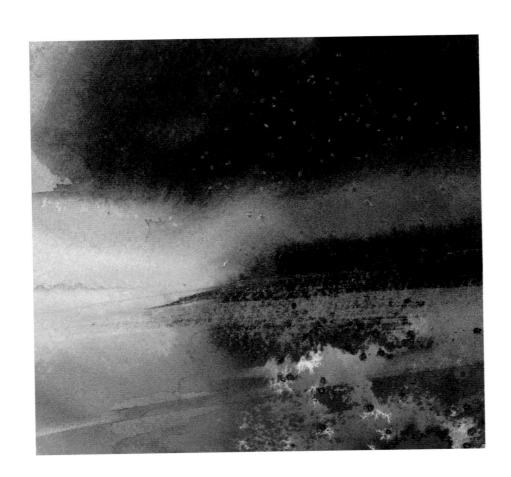

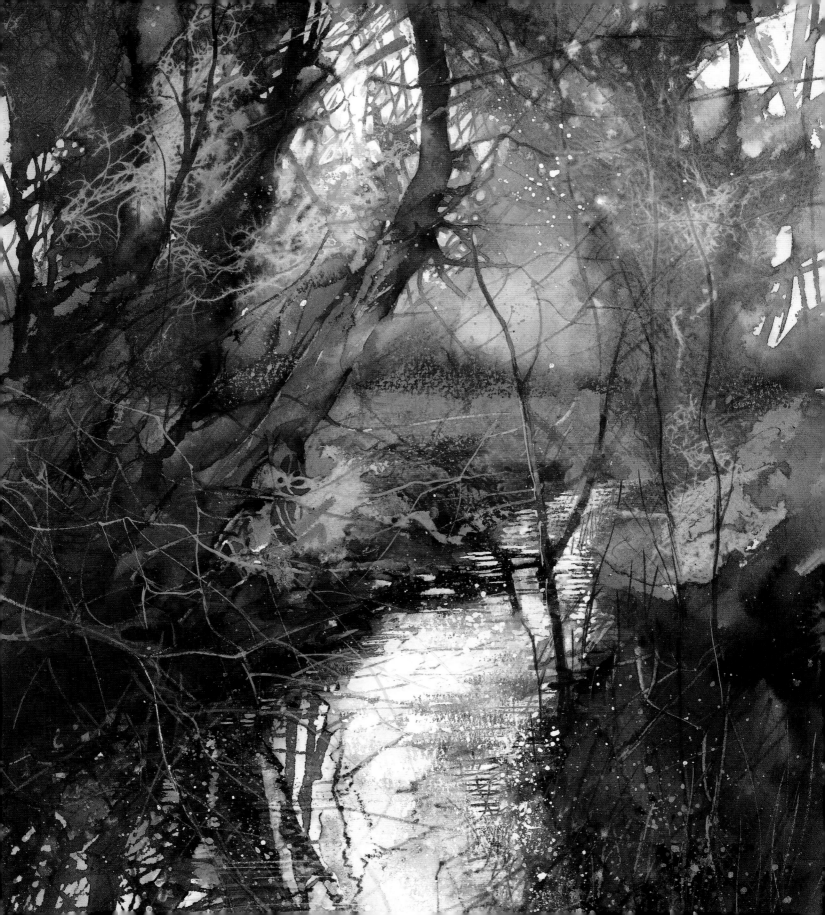

Experimental Landscapes in Watercolour

Ann Blockley

BATSFORD

First published in the United Kingdom in 2014 by
Batsford, an imprint of Pavilion Books Company Ltd
43 Great Ormond Street
London WC1N 3HZ
www.pavilionbooks.com

ISBN: 9781849940900

A CIP catalogue record for this book is available from the
British Library.

25 24 23 22 21
10 9 8 7

Reproduction by Mission, Hong Kong
Printed and bound by Toppan Leefung Printing Ltd, China

This book can be ordered direct from the publisher at the website:
www.pavilionbooks.com, or try your local bookshop.

Dedication

For my family: James and Tom, Pam and Andrew. And to Kevin,
for being my rock.

Acknowledgements

To all you lovely readers I would like to reach out with a massive
thank you. Without you, this book would not be possible.

Page 1: *Seascape* 11.5 x 11.5 cm (4½ x 4½ in.)
Page 2: *Woodland Reflections* 39 x 28 cm (15 x 11 in.)
Below: *Landscape in Blue* 10 x 46 cm (4 x 18 in.)

Contents

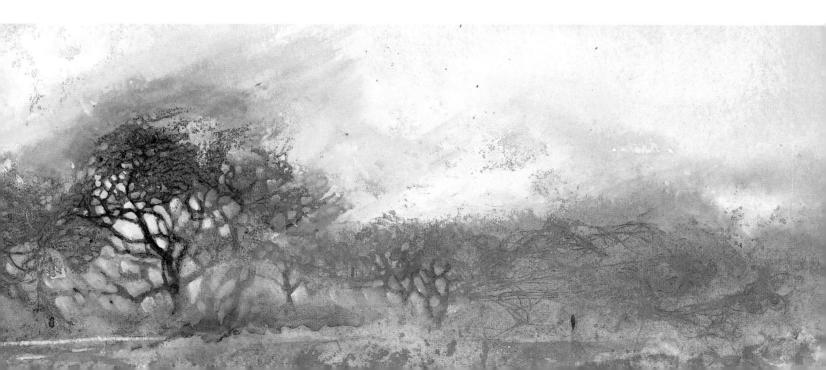

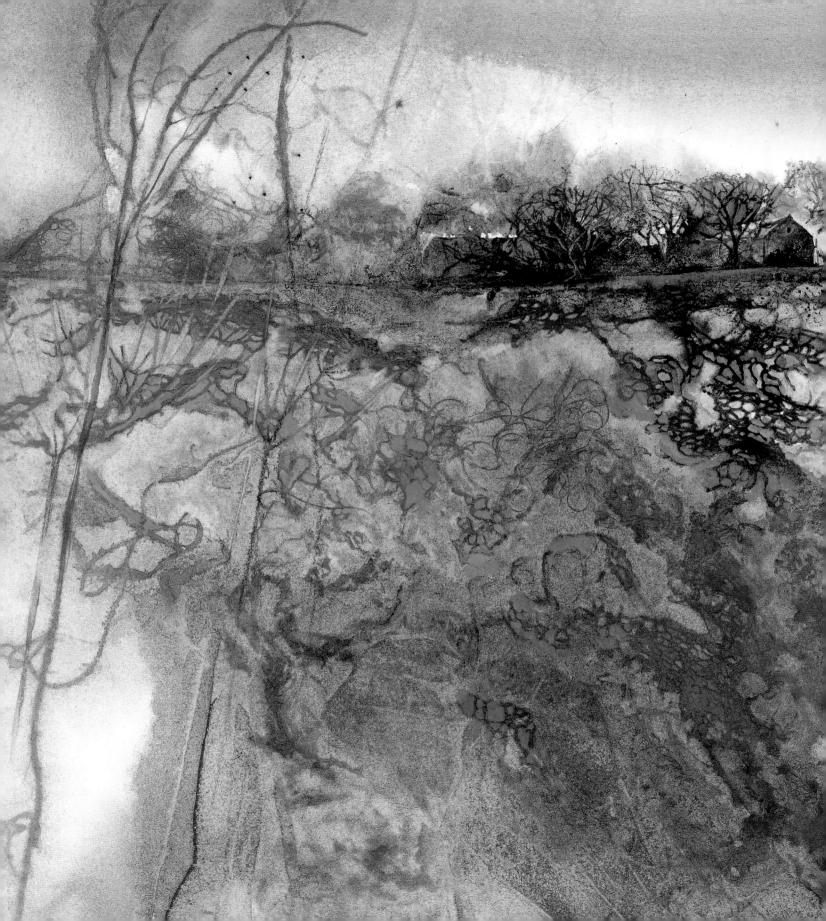

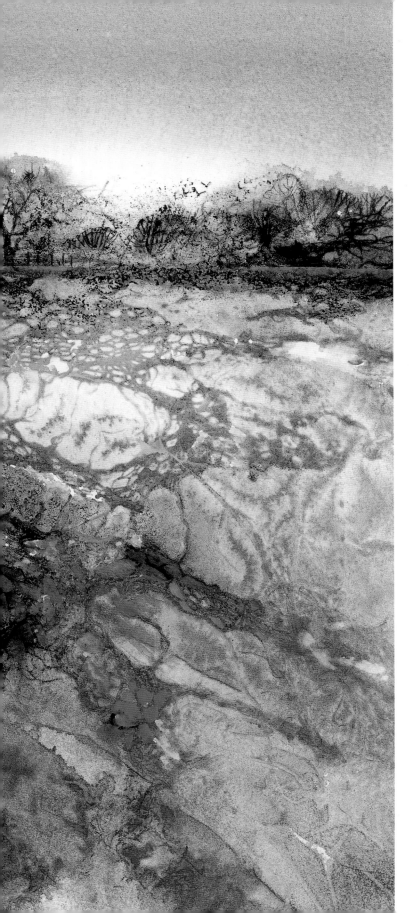

Introduction

In this book I want to lead you through some of the rich store of possibilities that experimenting with watercolour and other mediums offers. By sharing some of my favourite methods and newest, most exciting ideas, I hope to encourage you to explore further on your own artistic journey. I would love to think that by sharing my secrets and passion for painting I will help you discover your own special way of creating personal interpretations of landscapes and nature.

The subjects in this book are more about evoking the atmosphere and mood of a place or moment in time than about painting a traditional scene. The aim is to feed our souls and explore the romance and beauty of the world around us through the magic of paint.

Towards the Barn
27 x 35 cm (10½ x 13½ in.)

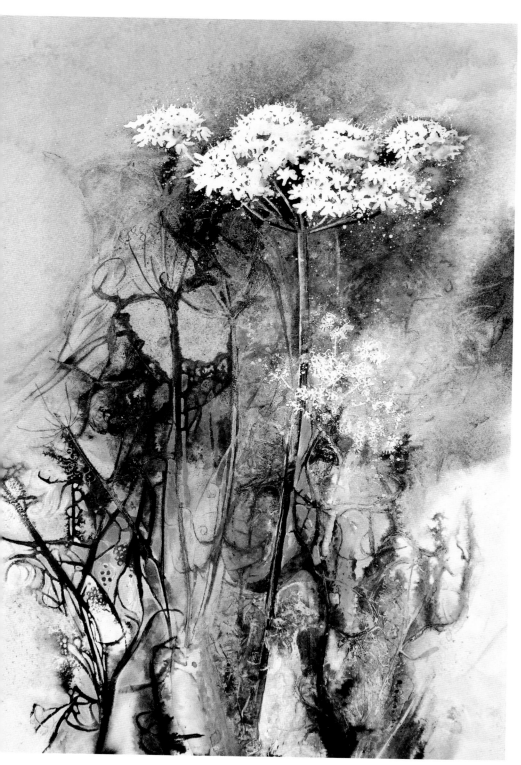

About this book

Painting a picture is like being a magician. We can transform the world through our paintbrushes, changing the weather and colours, getting flowers to grow and making things vanish or appear. Through our pictures we can play the most wonderful game of pretend, which is only limited by our imagination. To nurture this and to grow as artists, we need to give ourselves permission to have fun and experiment in painting. I explored this theme in my previous book, *Experimental Flowers in Watercolour* – the aim was to encourage artists to challenge themselves and try new ideas.

It became clear to me, on this earlier journey, that the abstract textures seen in flowers and their backgrounds echo those within other landscape subjects. I felt encouraged to start exploring further, using the landscape as inspiration. The organic, natural shapes and textures that I was familiar with were easily adapted to paintings of trees, foregrounds, skies and land. My explorations had led me to develop a way of looking at subjects in a more abstract and imaginative style. I had also proved to myself, through teaching others, that the combination of playing with paint and undertaking a series of open-minded paint experiments really can help to shift old ideas or affirm current ones.

Summer Hogweed
50 x 33 cm (19¹/₂ x 13 in.)

This book offers a wide range of methods for you to experiment with and combine in different ways to develop an original way of working. My finished interpretations of landscape and nature are included to give ideas for where you might use the techniques and to inspire you to explore further.

The first chapters focus on practical advice about how to experiment with a range of really exciting methods. Researching and choosing the techniques that suit you is part of the journey towards finding your own voice. Basic traditional watercolour and brushwork techniques have not been described in depth, as there are many other books that cover these topics. The emphasis is on painting in loose, expressive and experimental ways using watercolour as well as other water-based mediums and plenty of added ingredients.

The middle section of the book looks 'behind the scenes', covering the background steps of gathering reference material and making original and creative decisions. It is important to play in order to learn *how* to paint, but we also need to be thoughtful and consider *why* we might paint something in a particular way in order to create a sincere and personal response to a subject.

In the final chapters I have included my own interpretations of landscapes and nature, using techniques described in the earlier sections. I describe the most significant methods, colours or thoughts behind each picture to give you ideas for how you might develop your own interpretations.

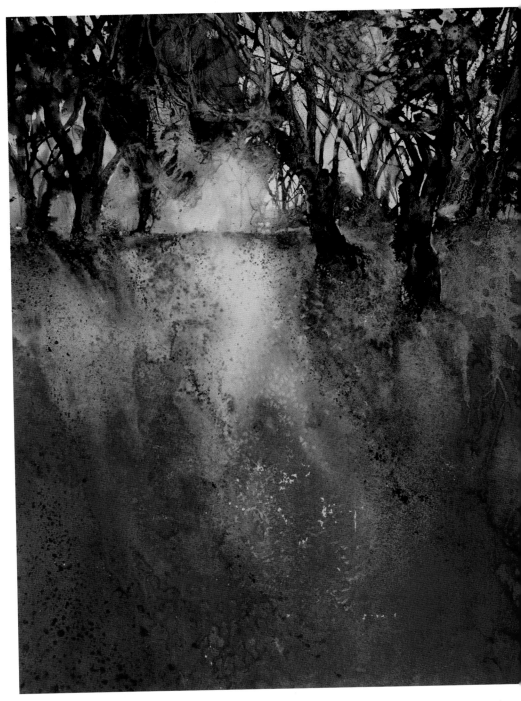

Bluebell Walk
76 x 55 cm (30 x 21½ in.)

Landscapes and nature

The area you live in can influence your choice of subject. I am based in the gentle rural landscape of the English Cotswolds. It is an area of hills, fields, hedges and woodlands. I am especially attracted to the close-up details of the landscape with their infinite variety of texture: wild flowers in the meadow, a bird in the brambles, a crumbling wall or a windswept tree. My interpretation of the word 'landscape' includes intimate views of these features as well as the wider picture. I think of all this as 'nature on the doorstep'. When I go on holiday, subjects such as twisted olive trees or rainforest ferns attract me; my eye is tuned to finding foreign versions of what I see at home. Every artist needs to stamp their own identity on their work, and painting subjects close to home and therefore closer to your heart can help you begin to identify and develop your style and interests.

Autumn Magic
28 x 34 cm (11 x 13½ in.)

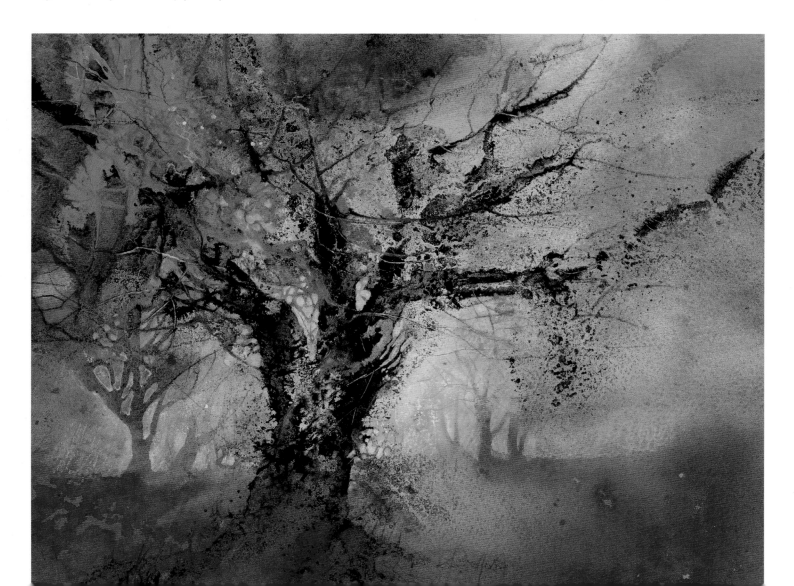

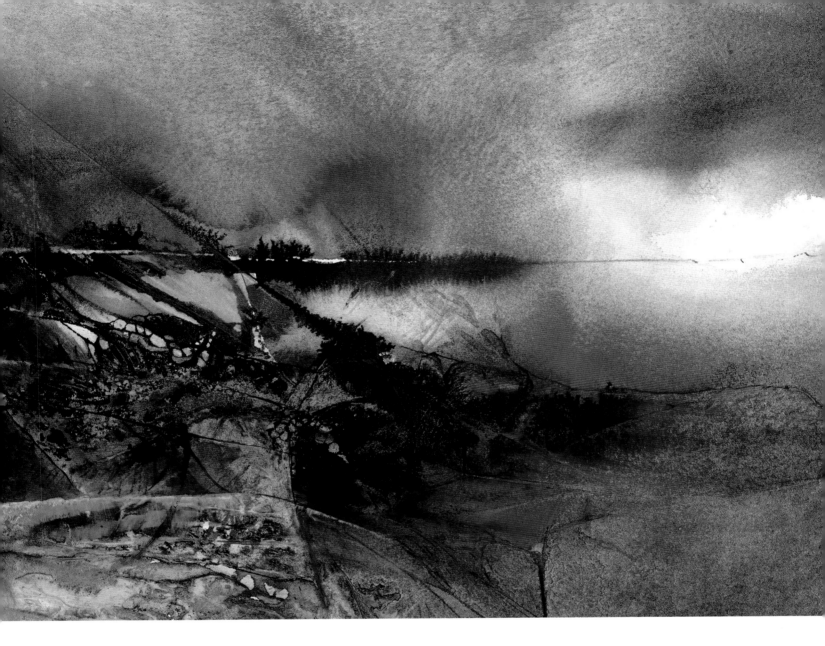

Making personal interpretations

In my research for this book, I explored a multitude of ideas and a wealth of amazing methods. At times I was sizzling with excitement at the vast potential that watercolour and paper have to offer. I soon realized that there would not be space for all my findings and so have carefully selected my favourite techniques. I hope you will enjoy experimenting with these and add your own personality to them. It is easy to feel that there is nothing fresh to say, but I believe there is always something new to be discovered. I hope that by sharing my passion for painting, you will look at the medium with fresh eyes and feel encouraged to create your own original landscape interpretations.

Landscape Patterns
22 x 28 cm (8½ x 11 in.)

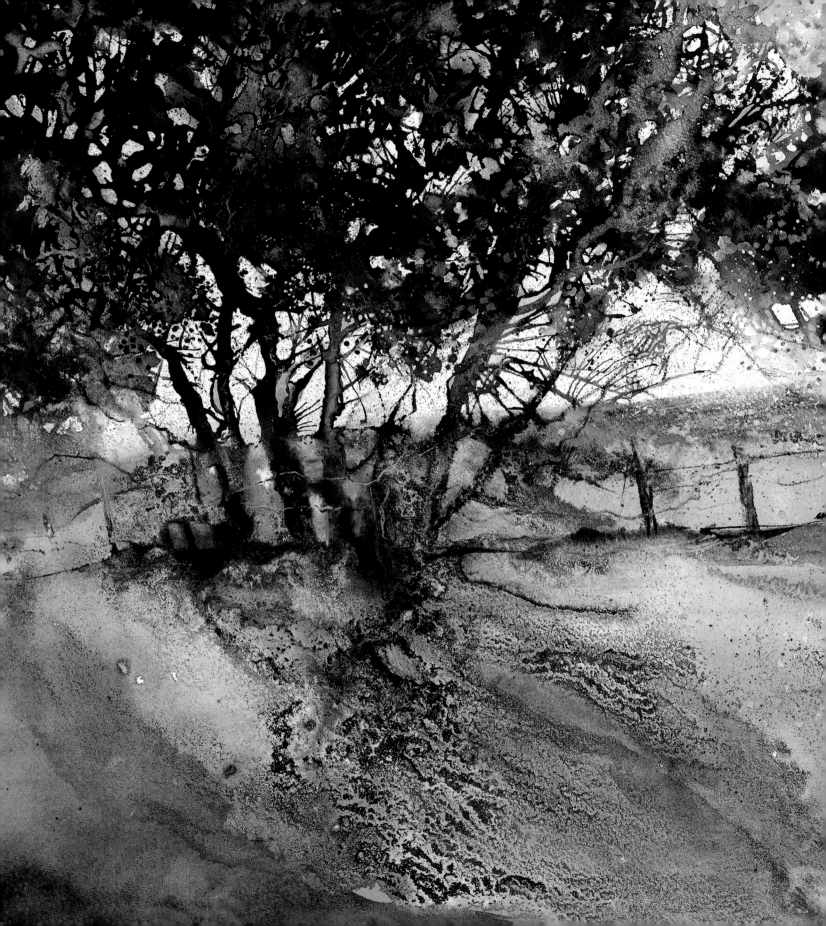

Methods
and mediums

Watercolour is a sensuous medium with its dreamy, translucent and flowing washes. Let us hold onto these qualities but complement them by exploring other water–based materials to make the process even more exciting and versatile. This chapter is about having fun creating unique textures and marks and manipulating washes. We will be using these to develop loose interpretations of, or allusions to, a subject rather than literal or detailed representations. Release yourself from the need to perform every time you paint, and work with a spirit of adventure. If you feel an exploratory piece is unsuccessful, I will be showing you ways to use or change it in the next chapter, so don't throw it away!

Sloes in the Hedge
36 x 50 cm (14 x 19½ in.)
The methods in this chapter are fun but often unpredictable, so experiment with different pigments on varying papers to discover what works best for you. Most of the paintings in this book have been made on Saunders Waterford Not or Rough in various weights.

Enjoying the qualities of watercolour

Throughout the book we will be looking at many techniques, combining watercolour with other mediums and manipulating both paint and surface to create interesting marks, textures and effects for painting landscapes. However, I want to emphasize at the beginning the necessity of enjoying and understanding the fundamental qualities of watercolour that underpin all these experimental procedures and are the key to successful painting. By this, I do not mean looking at the so-called 'rules' of watercolour about how to create perfect washes. I mean exploring the full potential and glorious possibilities of such a versatile medium. This means letting the paint flow and allowing the 'happenings' and magical effects that artist's-quality watercolour will naturally create if you give it permission.

Watch how certain colours push others around whilst others mingle in a friendly way. Combine opaque and translucent pigments. Paint on wet or dry surfaces or a mixture of both. Be playful with your paint and give it some freedom. Being free and loose with watercolour is more about letting go than technique. It may help to think 'lose' instead of 'loose': lose yourself in the paint; lose a little control. Lose edges and gain expression and vitality. Let the actual quality of the painted work, with all its joyful textures, luscious washes and abstract properties take precedence over painting the reality of a subject. Try not to be tempted to 'tidy up' your paintings. Let's be messy and have some fun!

It is important to experiment and practise applying watercolour on a regular basis for its own sake without always thinking in terms of the finished picture. Celebrate and enjoy your marks and washes and paint, paint, and paint again until you understand how they work. You will still get surprises, but your work will be loose and full of expression.

1 Paint on a dry surface to achieve ragged edges. Use only slightly diluted watercolour to create a dark, patchy wash.

2 Let back-runs develop by allowing pools of wet paint or water to flow back into a drying wash.

3 Dilute several colours to a milky consistency and let them blend themselves together on damp paper in a wet-into-wet wash.

4 Spray the paper lightly with water to create mottled washes. The watercolour should flow into the sprayed droplets and leave sparkles of white where the paper is dry.

5 Skate-paint lightly over dry areas to leave speckles and patches of white within the wash.

6 Remember to use plenty of water in order to achieve areas of pale, glowing, translucent watercolour.

Expressive watercolour mark-making

We all know that you can paint watercolour with a brush and there are many types available for different purposes. However, to create an even wider language of expressive or quirky marks, you can apply paint with all kinds of tools and materials. For example, you can splodge paint on with crumpled cloth, soft tissue paper or cotton wool, or use a sponge roller for mottled textures – I have an old one with a distressed surface that creates really patchy areas. Drag pools of paint into lines or scribbles using the end of the brush or another sharp tool. Flick dilute paint from the tip of a palette knife for controlled speckles, or shake drops of paint off your brush for bigger splodges. Print-paint with anything you can think of, including your fingers! Some of my favourite printing tools are paint tube lids or pieces of card (straight or bent, thick or thin, cut to different lengths). The geometric marks these make are especially useful for fence posts, grasses and buildings. Try spreading thick paint using a piece of hard plastic or a spatula. These alternative types of application often look more natural and spontaneous than the more controlled marks you make using a brush.

Don't forget that some of the most expressive effects are created when you allow paint to create its own patterns. Let it dribble down the page or encourage rivulets of wet paint by tilting or curling the paper in different directions, directing the colour where you want it go. Be inventive. Look at your subject and mimic it with the application of paint. In my own work, I mostly establish a painting with brushes and use other tools for additional mark-making. Experiment and see what works best for you.

A range of marks

I have used the following brushes to create the example shown left, and the paintings throughout the book:

- Flat brushes in various sizes for bold, crisp, geometric marks.
- Rigger brushes (size 4 or smaller) for long, flowing, linear brushstrokes. These are especially useful for rippled effects or plant forms such as grasses or branches. Use the very tip for tiny details.
- Round brush (size 18) for large wet-into-wet washes; size 8 for smaller areas.

1 Slabs of watercolour applied with a 5 cm (2 in.) flat brush.

2 Textures made with a roller.

3 Prints made with the edge of a piece of card, sometimes dragging it sideways to make thicker shapes.

4 Brushmarks made with a rigger.

5 Dribbles encouraged by tilting and moving the paper around.

6 Lines dragged from the wash using the handle end of a brush, and speckles shaken from a loaded brush.

Acrylic ink

Artist's acrylic ink is liquid colour that can be diluted or used straight from the bottle, or even poured directly on to your picture. This makes it a great choice for direct, spontaneous work. It can be painted and manipulated using most of the methods described in this book, either on its own or combined with other mediums. For example, you can add ink to a watercolour wash.

Ink differs from watercolour in that it is waterproof when dry, which means that you can only lift colour while it is still wet. It is not so suitable for use with methods that rely on a very thick consistency, although some pigments are thicker than others. Colours are either opaque or translucent; the former are often slightly thicker, and are the ones to try when experimenting with granulating effects. It is vital, when choosing ink, to make sure that it is lightfast or permanent. You do not want your masterpiece to fade! Ink is usually supplied in bottles, often with a pipette in the lid. These are useful tools for doodling, scribbling and squirting colour, and of course you can keep the empty bottles and fill them with diluted paint afterwards.

Forest Ferns
37 x 55 cm (14^1/$_2$ x 21^1/$_2$ in.)
In this vibrant interpretation of ferns in a woodland setting, I used actual ferns to create imprints as described on pages 38–39. The colours I chose were Indian yellow, sepia, turquoise, burnt sienna and gamma green acrylic inks.

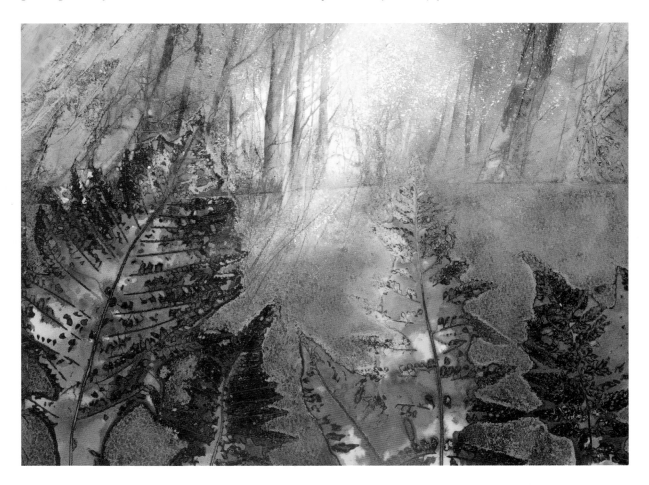

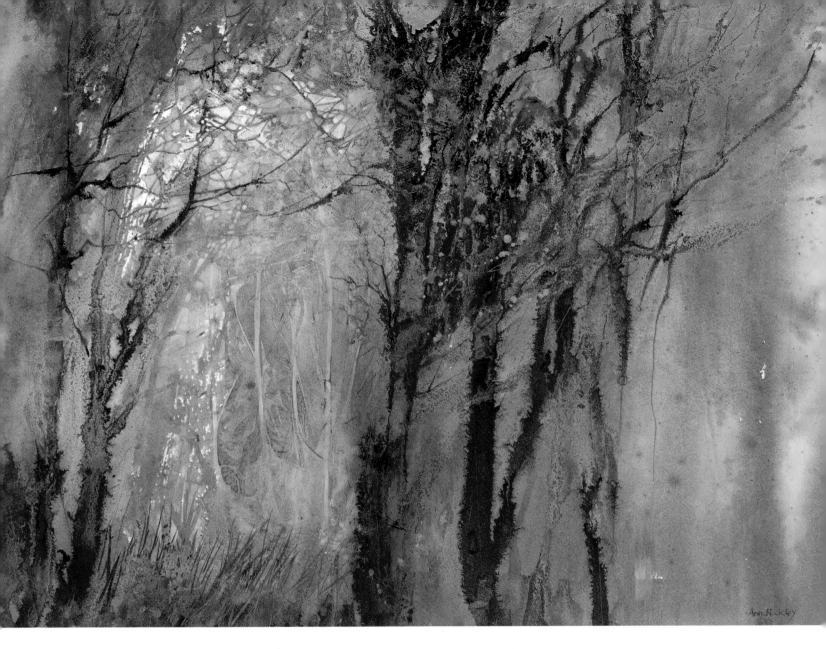

Woodland Light
39 x 50 cm (15$\frac{1}{2}$ x 19$\frac{1}{2}$ in.)

We tend to think of inks as being extremely vibrant. However, in recent years a much wider range of colours has been developed by a variety of manufacturers, and you can create quite subtle paintings, especially when you mix inks together. *Woodland Light* used colours including sepia, antelope brown, yellow ochre and gamma green inks combined with French ultramarine watercolour and some white gouache.

The versatility of gouache

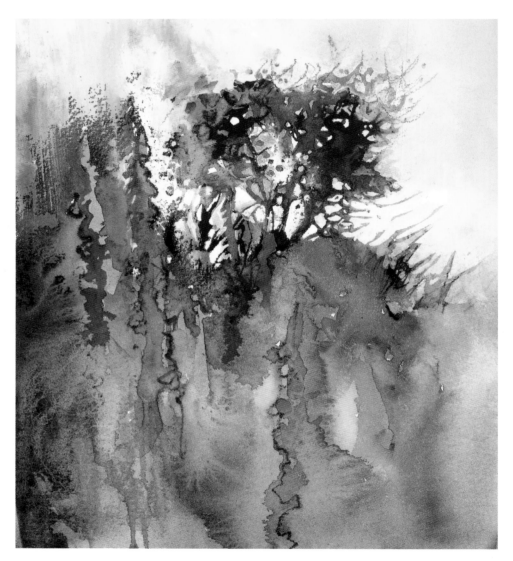

Gouache is similar to watercolour, but modified to make it opaque. Its opacity gives you the option to paint light on top of dark, or build layers of different colours – which opens up a world of technical possibilities. When using translucent watercolour, you mainly need to work from light to dark and plan the order of colours. You have to be organized to do this, working towards a specific aim. There is more flexibility in combining watercolour with opaque mediums. You can still have translucent areas, but with more opportunities to change and redevelop what you paint. Opaque paint allows you to create order out of a loose 'beginning' – you can cover up certain parts of the composition, conjure subjects out of the background using negative painting, adapt marks or shapes, make an area paler, and create gaps. This versatility can help to make watercolour painting a less intimidating process, which means that you can afford to be looser and more daring.

You can create an entire painting from gouache. My own preference is to use watercolour or ink for the initial washes and add gouache to parts of it while it is still wet, or make adjustments when the first layer is dry, leaving as much of the original statement as possible.

Foxgloves in the Wild
16 x 16 cm (6¼ x 6¼ in.)

This painting began with a watercolour wash to suggest foxgloves in a dark background. The shrub was developed from this using gouache to paint the negative space around the dark foliage and add small shapes to describe the gaps between branches. I scraped the damp gouache to reveal grasses and make twiggy marks. At the top left, you can see where I dragged the gouache roughly downwards. I allowed the watercolour wash to shine through the diluted gouache without adding further layers.

More useful tips for gouache

Like watercolour, traditional gouache is not waterproof. I say 'traditional' because there are new, acrylic-based gouaches available and these, like acrylic paints, are waterproof when dry. I have not included any acrylic paintings in this book, but you could use acrylic as an alternative to gouache, except for any techniques that require the re-wetting of dry paint. If you apply normal gouache over a dark wash, you can dampen after it has dried and scrape through it to reveal the colours underneath. This is really useful for branches, grasses and foreground textures. Another idea is to dampen and blot the gouache for cloudy effects or patchy foregrounds.

Gouache can cover a watercolour wash entirely or partially, depending on the effect required. You can build it up in layers until you achieve the level of opacity you require. Use the paint undiluted if you want full coverage or a dry, chalky effect, and add water to achieve a milky glaze. There is a wide spectrum of colours available, but I find white gouache particularly adaptable as it can be used on its own or tinted with watercolour or ink to create paler versions of colours already used. I often use it to make negative shapes on top of a wash, developing gaps between subjects such as light shining through trees.

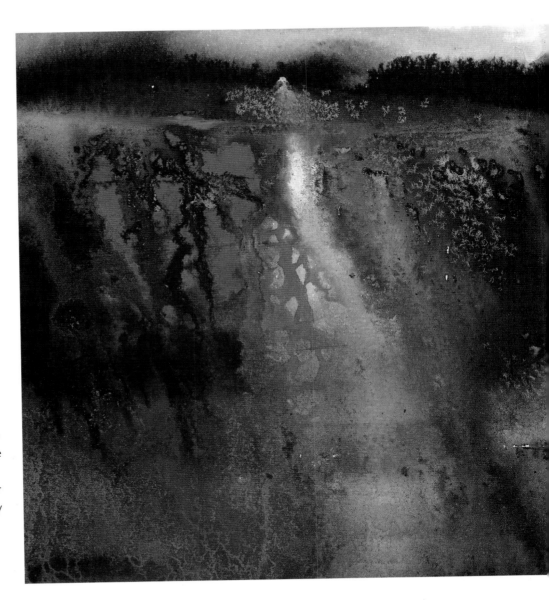

Velvet Twilight
15 x 15 cm (6 x 6 in.)
A useful tip for creating skies and atmospheric, misty effects is to add a small amount of white gouache to a watercolour wash. Here I created a mysterious pathway using this technique. I also used purple gouache to add opaque patches of colour on top of the background.

Drawing materials

There are lots of different mediums to draw exciting marks with, and these can be used in conjunction with water-based mediums as well as on their own. If you experiment with a wide variety of drawing materials, it will help you to develop your own particular favourite combinations and literally 'make your mark'. Drawing into your pictures is a sure way to make your work individual, as your signature will shine through marks and lines in a way that is more elusive to achieve with pure paint. The following materials are the ones that suit me, but do share your materials with friends so that you can try out as wide a range as possible and find your own favourites.

Oil pastels, when applied firmly, will resist and shine through washes of watercolour. This is handy if you are painting flowers in the landscape and want speckles or spots of colour within a field. You can create broken textures on a Rough or Not surface by using a stick of oil pastel on its side. Press firmly, as otherwise the marks will not show up after the wash is painted on top. Alternatively, you can use the oil pastel over a dry wash. This is particularly useful for highlights and accents of colour that can really lift a painting.

I like Inktense sticks by Derwent. These are sticks of colour meant for drawing and painting with. Try using them on their side to create chunky broken marks, especially into a damp wash. Shave them into a wet wash to create speckles, using a knife for a varied texture or sandpaper for finer speckles. Imagine enriching lichens, sandy beaches and rocks with these textures. You can create similar shavings with a watercolour pencil, and I also like using these to draw into work. Barbed wire fences, grasses, branches and 'scribbles' are all likely candidates. You could try crayons, charcoal, graphite or soft pastels on top of watercolour but remember that if your medium is water-soluble, you may need to make marks in a particular order to avoid smudging.

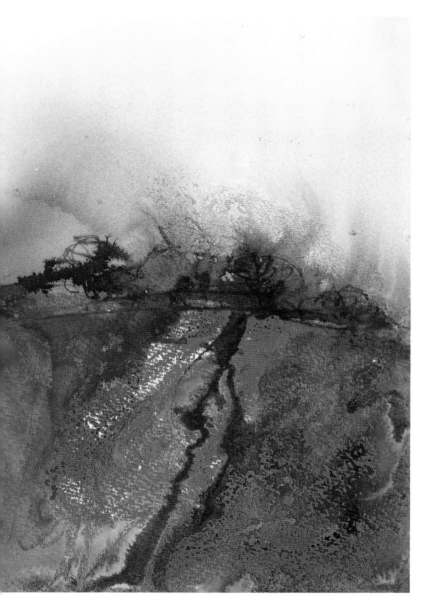

Field textures
Rub oil pastel on to Rough paper and brush a wash of a different colour on top to make a broken texture.

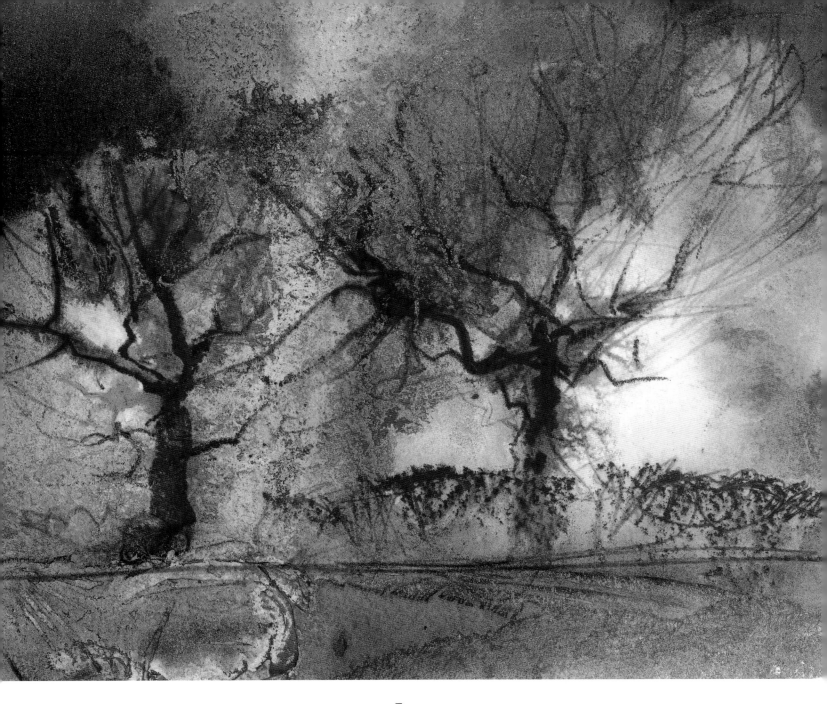

Tree textures

Use watercolour pencils to draw into washes and describe trees and branches. You will achieve a dense smudged line on wet paint and harder-edged lines on dry paint. Use pastels or Inktense sticks on their side to draw hedgerows.

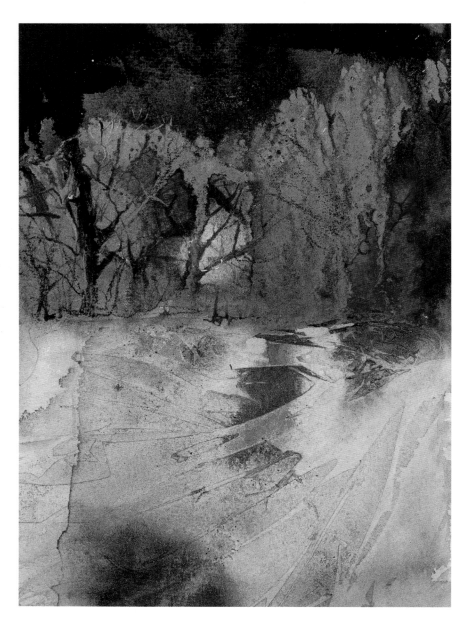

A bit of 'bling'

I think we all secretly enjoy a bit of sparkle and glamour, and in the context of landscapes, a little gold, silver or iridescence can really add a feeling of magic and mystery. You can create a fairy-tale aura with a subtle shimmer. Maybe you want to create an exotic or oriental theme, or perhaps you want your picture to be rich and decorative?

There are lots of materials to choose from and they are all fun to experiment with. A long time ago, I found a pot of gold in my garage! It was oil-based and therefore reacted with the watercolour, marbling into marvellous textures. I have been asked countless times since what this magic ingredient was. Alas, my gold has gone and I have never been able to track down the same thing. Fortunately, there are lots of other products available.

Gold and iridescent inks can be dripped into paint and allowed to spread into washes for a subtle effect. Alternatively, you could paint specific shapes such as a moon, stars or sun. Metallic-coloured gouaches and acrylics can be applied thickly, but these are not usually very sparkly. Alcohol- or oil-based products tend to be shinier. If you want a real gleam, use little bits of gold or silver leaf. The imitation sort is cheaper and does not tarnish. Use your own judgement as to what is tasteful and appropriate. There are no rules!

Golden Treetops
24 x 17 cm (9¹/₂ x 6³/₄ in.)
This picture is based on a magical woodland near my house, where rooks cry from the treetops in a cacophony of sound as the sun goes down. To capture a sense of this potent atmosphere I used gold ink, pouring it into washes of coloured inks and giving it the freedom to spill into the foreground like moonshine in the clearing.

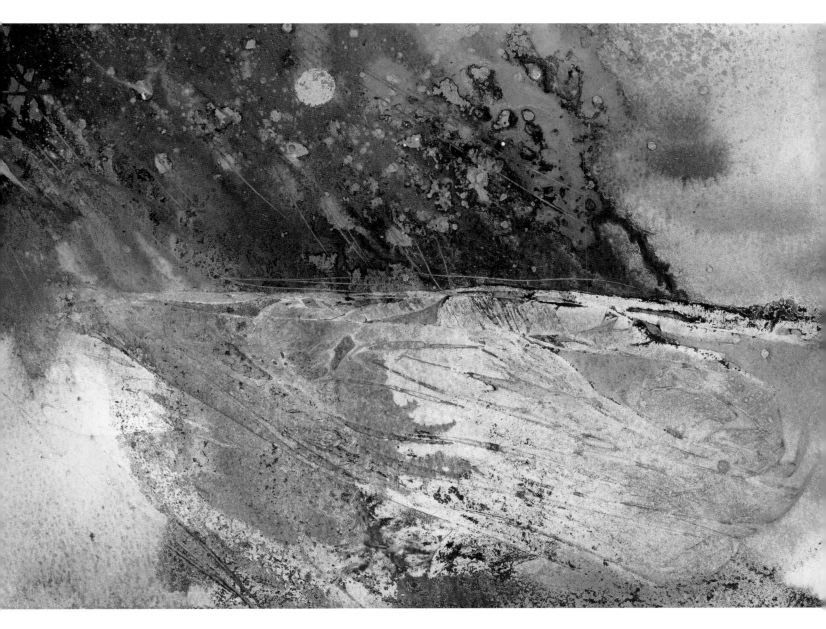

Magic in the Air
20 x 26 cm (8 x 10¼ in.)

I sprinkled a Schminke product called Tro-col-bronze into a watercolour wash to create shimmery textures. This bronze powder contains a dry gouache binding medium and is available in different metallic colours. I used the tip of my palette knife to scatter larger areas and spatter tiny speckles. I added a little broken circle of gold leaf to indicate a moon or something magical in the air.

Scraping, scratching and cutting

You can lift or remove colour from a watercolour wash with a brush, sponge or special eraser for soft, pale marks. To achieve more dramatic, hard-edged shapes, try scraping paint out using the edge of a scalpel, a piece of hard plastic or some card. You can create geometric shapes that are perfect for rocks, tree trunks, walls and foreground textures. You need to use paint of a creamy consistency: if the paint is too thin, it will just flow back on itself.

Sometimes, a little thick paint is pushed to one side as you scrape, and this residue creates a dark shadow. If you use a sharp tool like the tip of a scalpel, you can scrape out thin, linear marks. Timing and pressure are crucial. If you work too soon or too firmly, you may dig into the paper and create a dark line where the paint sinks into the grazed paper rather than removing paint from the surface. You can use this effect to your advantage and make a series of lines, from dark to pale. You need to work quickly before the paint dries. If the paint has already dried, you can re-dampen it with a spray and scrape colour away, but only if the watercolour is thick enough and not too dilute. On smooth paper you will get cleaner-cut lines and edges than on rougher papers. You can also experiment with painting a wash in one colour and then scraping through a second layer of contrasting colour to reveal the first.

Another idea is to scratch into the paper itself with a scalpel. You can scratch broken lines or flick out dots to reveal the white paper. To create clear-cut white marks within a dry wash, use a sharp craft knife or scalpel to gently cut into the top layer of paper. The paper needs to be at least 300 gsm (140 lb) in weight to prevent you from slicing completely through it. Make shapes such as strips or a circle, depending on the subject, then peel them away to reveal the bright white underneath.

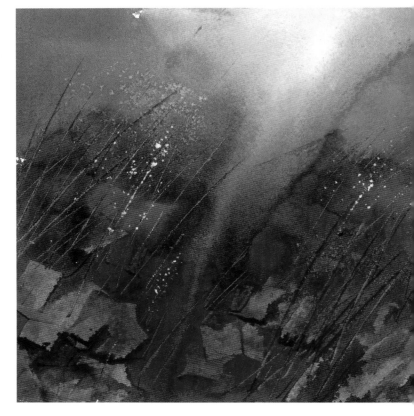

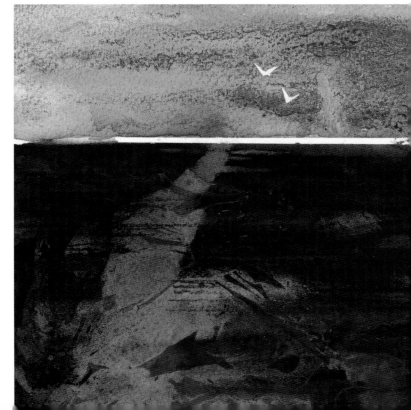

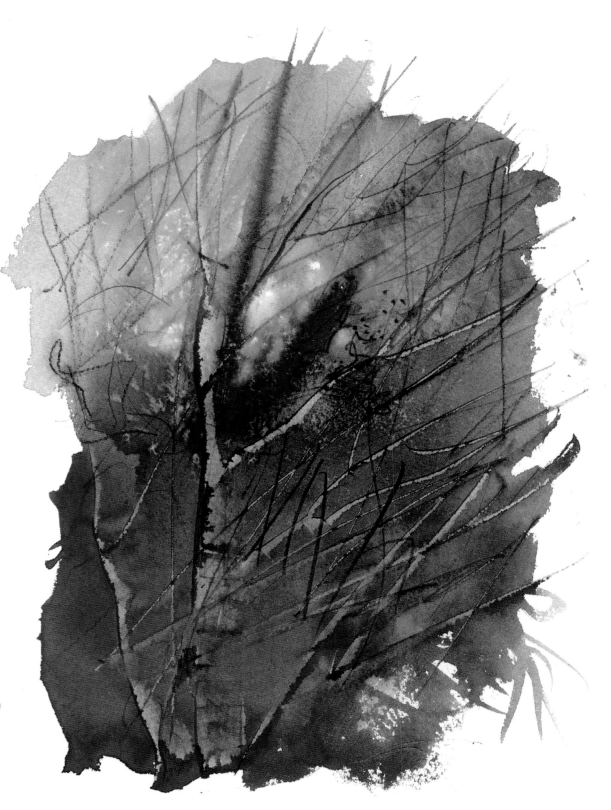

◄ Scraping to make rocks and grasses

Use thick, creamy washes of colour to represent the sky and foreground. When it starts to dry, use small pieces of credit card to scrape out rocks and a sharp tool to scratch out grasses and tiny dots for seeds.

► Scraping to make branches

Paint washes of full-bodied watercolour and then use a sharp-edged tool to scrape away paint to form branch-like shapes. Work swiftly for a loose effect. Dark lines may appear along the edges, and you can supplement these by drawing twiggy lines with a dark watercolour pencil.

◄ Seagulls and Light
16 x 15 cm (6¼ x 6 in.)
I liked the colour and textures in this little semi-abstract experiment, but it was lacking in content. So I cut partially through the surface of the paper in straight lines and pulled the top layer away to reveal a strip of light, then created some seagull shapes in the same way.

Salt techniques

There are many different ways of using salt to create natural textures. When you add salt to a wash it absorbs paint and creates pale, speckled effects. These vary according to the size of the salt crystals, the amount used, how it is put on, and the paint it is applied to. Table salt makes the finest speckles, with rock and sea salt creating bigger, snowflake-type markings. For subtle sparkles, use your fingertips to gently sprinkle a few grains into a wash that is still damp, but when the shine is disappearing from the paper. Be patient, as salt can be slow in making its magic and it is very tempting to add more. If you pile too much salt into one place, it may push the watercolour into a back-run. If you pour directly from the pot, you may also get an over-dramatic texture. It is just like cooking: too much salt can spoil the recipe!

Try throwing the salt on sideways, or tilting the paper so that the salty paint moves and blurs. Experiment with sprinkling a few specks of fine sea salt into creamy paint and blotting it off when the paint is almost dry to get small, hard-edged dots. You could also try combining different sizes of salt crystal within a wash, or experiment with using seawater to see what happens.

Salt textures have a multitude of uses including foliage, stonework and water sparkles. They create atmosphere and movement. Try, for example, using just a few individual crystals to create a small cluster of specks to suggest, for example, a few distant birds in the sky.

Subtle salt textures

Remember that less can be more when using salt. Aim for a subtle effect to prevent it from looking gimmicky. In this foliage sketch, I used a mere sprinkling of salt to give an impression of shimmering foliage.

▲ Foliage and foregrounds

Salt is ideal for foregrounds and foliage. You can give the impression of a sandy beach, pebbles and stones, lichen and leafy bushes, treetops and undergrowth. Try sprinkling droplets of water into a salted wash to vary the textures.

Water sparkles

Paint a wash and sprinkle the grains carefully where you want to add glittering sunlight on water. Always rub any salt away when everything is dry. In this example I masked a hard-edged horizon using masking tape before applying the lower wash.

▶ Weather effects, skies and movement

Tilt your paper after applying salt to move your still-wet wash slightly in a particular direction suitable to the flow of the picture. This changes the texture so the salt develops into a marbled effect that creates an unusual impression of movement.

Granulation speckles

To create speckles, paint a wash and immediately add a small amount of ink to it. This could be the beginning of a tree, a distant hedgerow or a rock. Immediately drip a little granulating medium into the new shape and begin gently jiggling the paper. The movement will help to separate the particles in the introduced pigment. It will not granulate so successfully if you simply leave it flat. Do not worry about the speckles spreading beyond the intended shape: it will add to the mystery and atmosphere of the piece.

Granulation textures

Granulation rivulets

To create rivulets of granulated texture, add random drops of ink to a wet watercolour wash made on unstretched paper. I used Indian ink on top of quinacridone gold and French ultramarine watercolour. Immediately drip the granulating fluid into the ink. You can apply it with a pipette to avoid pouring out too much. Now tilt and move the paper, even bending it to help the fluid run in tiny streams and break through the pigment. Add more fluid or a little water if it is stubborn.

Granulation is the process in which particles of watercolour pigment settle in the hollows of paper, producing a mottled effect, and it adds visual texture to a painting. It is generally the traditional pigments that granulate, such as cobalts, earths and ultramarine. Raw umber, cobalt blue and violet, French ultramarine, magnesium brown and potter's pink are a few of the good granulating colours in the Winsor & Newton range. The Daniel Smith company has created a Granulating Watercolor Set, which contains some of their most granular pigments. With names like lunar black and lunar red rock, you can imagine the extremely pronounced granulation effects that they create naturally.

Although many pigments granulate naturally, Winsor & Newton have a product for increasing the effect, called granulation medium. I prefer to add drops of this clear liquid into a wash rather than mix it with paint as described on the bottle. You can also try using it with coloured inks. The opaque ones seem to work best. Indian ink also splits into dramatic flecks and specks but will do so by simply adding water. Use this rich black very sparingly, as it spreads further than you think and can easily overpower a painting.

Clingfilm patterns

You can make fabulous abstract shapes and patterns by placing clingfilm (plastic food wrap) on a wet wash, over all or parts of the composition. This is a great way to add texture without being too literal. The idea is to mimic reality whilst being sensitive to the characteristics of the subject. You can apply clingfilm in many ways, but the results will vary according to its thickness, the surface and the pigments.

Clingfilm emphasizes the qualities of the underlying surface of the paper, so the rougher the paper, the more pronounced this secondary texture will be. You can use large pieces over big areas or tear off small bits and place them in appropriate positions. Dark marks generally form where the plastic falls and presses the wash against the paper, and the paint will stay paler where the plastic stands away from the surface. You can continue to manipulate the clingfilm once it has been arranged on the wash. All this must be done while the paint is wet, as clingfilm will not work its magic on a re-dampened wash.

If you intended to use clingfilm but the wash is too dry, you could use some in another wash layer on top in a contrasting tone or colour. The effect may be less dramatic, but it should be subtle. Either way, the painting has to be left to dry naturally, as if you use a hairdryer, you will simply blow the plastic away! If you lift the clingfilm too early, the paint will seep back into itself and you will lose some of the texture. The length of time you have to wait depends on how wet the paint is and the temperature, but allow a couple of hours in normal conditions.

Standard clingfilm textures

One simple way to use clingfilm is to crumple it and place on top of a wet wash. This disturbs the paint into shapes that might represent rocks, a wall or foreground textures. Stretch a different piece of clingfilm into pleats to make a striped pattern. Laid vertically or diagonally, stripes might represent woodland, grasses, or the texture of doors or fence posts. Placed horizontally, you could suggest water ripples. Position stripes along the contours of a landscape for a furrowed effect, using different pieces for changes in direction. Use dark colours for contrast and pale colours for a more discreet finish. In the example here, I placed separate small pieces of clingfilm in the foreground to give the broken, patchwork effect of earthy fields.

Rosehips in the Hedgerow
28 x 46 cm (11 x 18 in.)
Clingfilm is not merely a device for making texture in small, specific areas. It can be used in a more general way to give your whole painting an abstract style. It instantly fractures the picture into complex networks of quirky shapes that would be hard to plan. You can work into these abstract patterns, emphasize or soften them in places, and even cover up unwanted areas with opaque gouache.

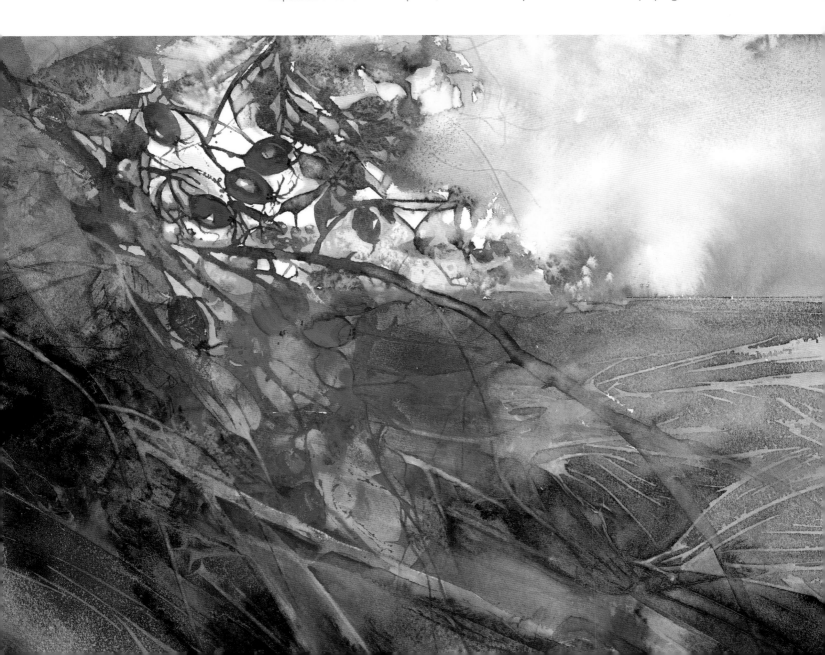

Further adventures with clingfilm

Try using different brands of clingfilm. Thick varieties create large patterns, whereas thin plastic sinks more into the pits of the paper. To exaggerate these mottles, rub or burnish the clingfilm with your fingers or the back of a spoon, smoothing out the furrows. Cut thick clingfilm into snippets or strips to create individual geometric shapes and apply them without crumpling. You could also try distorting the clingfilm before using it in the normal way. Stretch and puncture it, or even melt it in places with a hot air gun so that parts of it shrivel. Another technique, which is fun to do, is to pinch and pull up the applied clingfilm from a central place to create a web of pattern.

If you are feeling adventurous, experiment with other plastics or papers to break up washes, such as plastic bags, cellophane, waxed paper and lightweight papers such as tissue paper. Use them flat, creased or crumpled. You may find that you need to weigh them down with a flat board to keep them flat as they dry. The textures created by crumpled tissue paper resemble those made with clingfilm. An added advantage is that the paint is transferred on to the tissue, making it a very useful collage material for later use.

Pouring paint under clingfilm

As the paint under the clingfilm begins to dry, tilt the paper and dribble more diluted paint underneath the edges. This process is unpredictable, so start with tiny amounts and experiment. The added liquid should flow through the little raised channels within the clingfilm creases, creating an incredible network of meandering lines.

Thick paint or opaque ink with clingfilm

If you use opaque ink or thick watercolour underneath clingfilm, it will form ridges as it dries, where it has squidged up against the creases of the clingfilm. This gives an added three-dimensional interest to the work.

Washing away damp paint

The rule when using clingfilm is to leave it on until the paint is dry. If you like breaking rules, try removing it when the paint is almost but not totally dry. Use a jug to carefully pour water over the patchy wash. The dampest parts are usually where the plastic was touching, and some of the paint in those areas should wash away to make these shapes even paler and more contrasting. Such excitement!

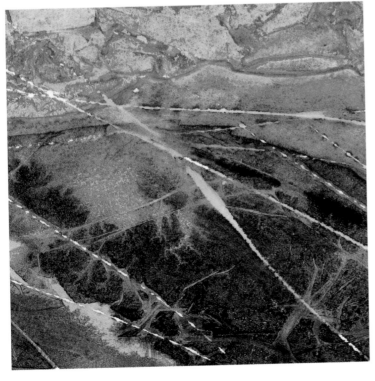

Combining clingfilm with masking fluid

Combining techniques can get complicated. Salt under clingfilm, for example, takes forever to dry. A more useful combination is to block out shapes or lines with masking fluid and use clingfilm over this when it has dried. The masking fluid can be removed later and the shape tinted as required. In this example, I made lines of masking fluid using the edge of a palette knife. The cloudy effects were caused by dribbling water under the clingfilm.

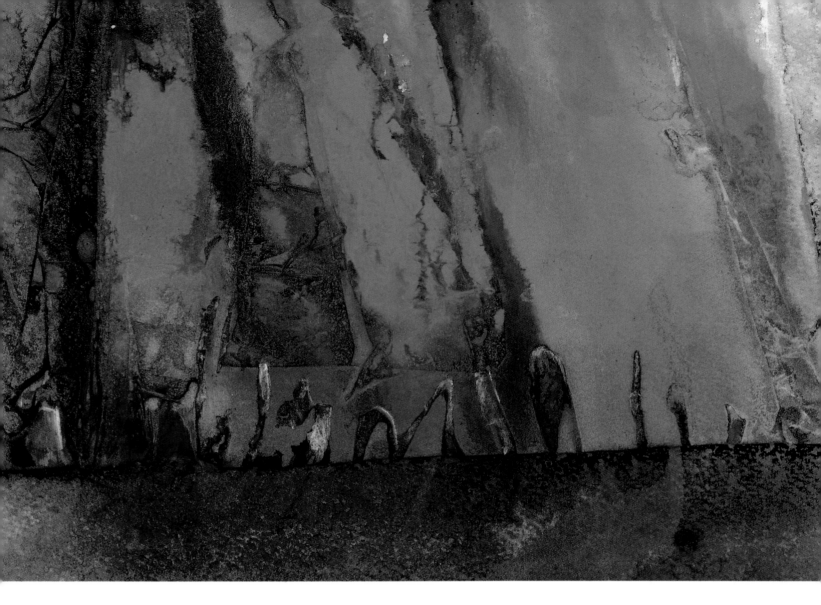

Cellophane

Cellophane is a clear plastic often used for wrapping. You can recycle it from wrapped purchases or buy it in craft shops. It is less flexible than clingfilm and so these flatter sheets create different effects when applied to watercolour. You can use large pieces for big areas like the whole of a foreground or a sky, or use smaller snippets cut into abstract or representational shapes. You can either place the cellophane pieces on damp, clean paper and drop colour around them, or position it on top of washes. Paint will usually only flood underneath if you encourage it to, otherwise the shapes stay crisp due to the hard-edged nature of the plastic. Sometimes an interesting seepage creates a ragged edge of colour. Used in this way, you retain a lot of control and it is a useful method for distinctive interpretations of hard-edged subjects.

The fun begins when you deliberately lift the edges of the cellophane and pour or drip more colour underneath. I find ink the easiest medium to use for this, as the liquid is ready-made and waiting to go. This is an adrenaline-packed, unpredictable method. With this in mind, make a large painting and be prepared to crop the resulting work to its most glorious sections.

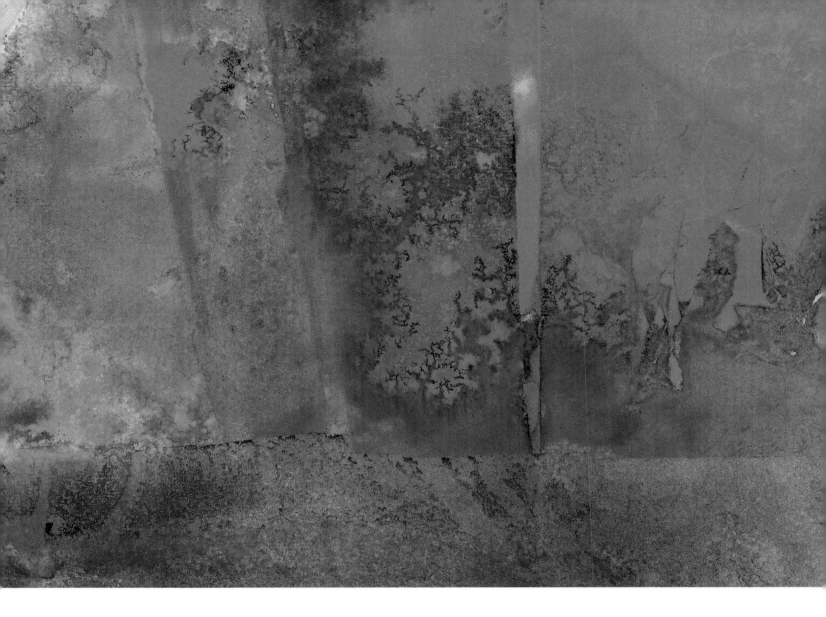

Standing Stones
21 x 52 cm (8$^{1}/_{4}$ x 20$^{1}/_{2}$ in.)

I painted a watercolour wash and then placed cellophane over the bottom third. I cut some small shapes and placed them in a row above this horizon and positioned another big sheet of cellophane at a slanting angle over the first pieces to break up the largest area. I then poured inks downwards from the top, under the cellophane, allowing them to make their own journey. I covered all this with recycled paper and weighted it down with a board until dry. Plastic often leaves a shiny residue. I enjoy this effect and employ it judiciously. It is difficult to add further paint onto the shiny parts, so if you wish to make changes or do not like the shine, you can gently sand it away with a fine sandpaper. I had planned to work into the result, but decided to leave it unaltered. The effect is abstract but conjures the impression of sunlight filtering through forest into a mystical line of pagan standing stones.

Printed impressions from found objects

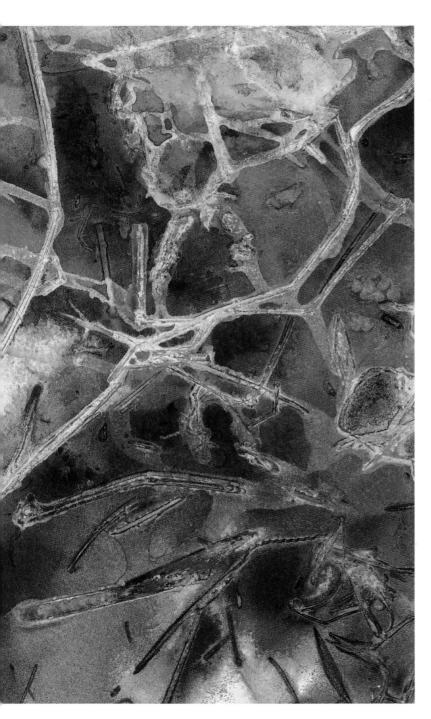

We have looked at ways of using cellophane to create unusual effects. Let's take this a step further and play with placing found objects underneath the plastic to print abstracted impressions on the paper. You can use natural materials such as plant parts, grasses, leaves or feathers; anything flat and decorative. You could also experiment with man-made materials such as embossed plastics, bubble wrap, sequins or fabrics. The main criterion is that it is flat enough to lie directly on the surface of the paper, so that the liquid pigment added can flow around and underneath it, leaving patterns and shapes. The exact results are unpredictable but often thrilling. Sometimes you get clear, recognizable prints of the subject; at other times the effect is more abstract.

I have tried different methods for applying the paint including brushing, spraying and pouring different water-based pigments on to a dry or wet surface for a variety of effects. Experiment to find what works best for you, but here is my favourite 'recipe'. I suggest that you protect the work surface before you begin.

Wet the paper and brush or pour on enough diluted watercolour or ink to make big wet-into-wet washes. If you are using watercolour alone, make sure it is dark enough for the results to show up. Place the objects on top and cover with a sheet of plastic. At this stage you can opt to pour more paint or ink underneath the cellophane, or spray water to help the pigment flow and gather around the placed material. Cover with newspaper to mop up leaks and place a heavy board on top. Leave this to dry and then discard the materials on top or clean and reuse them.

Dried grass and straw

This pattern was created with some dried grasses pulled out of a hedge and placed on a coloured wash. The addition of white and brown inks poured under the cellophane resulted in a combination of pale and dark marks. The organic material was used to create a fretwork of texture rather than to represent the actual grasses.

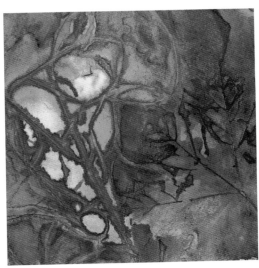

◄ Raffia and leaves

The process of combining materials and different found objects will create further ideas for pattern and texture. In this example I combined maple leaves with some scrunched-up curls of raffia.

▼ Primrose leaves and ferns

In this example I used primrose leaves and ferns. The ink has caught around the veins and edges of the primrose leaf, but left an almost stencilled effect around the ferns. You could use impressions like these to depict foreground details within a landscape context.

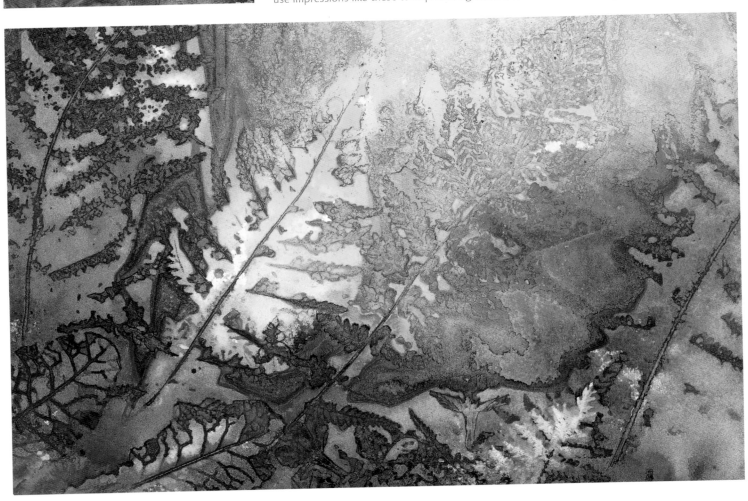

Creating texture with fabrics

Using the techniques described on the previous page, you can use different fabrics to transform washes into gorgeous textural effects. As fabric is absorbent, it soaks up pigment and then transfers it back on to the paper as it dries, 'printing' a dark impression. The extent to which lines and marks are defined depends on the wetness of the paint and the characteristics of the material used. It may not be necessary to weight down your fabric experiments with cellophane and a board, as the weight of the soaked fabric may be enough to keep it in contact with the paper. The best results are made using open-weave fabrics that can be distressed, ripped or pulled apart to make more random patterns. Try using scrim, cheesecloth, lace fabric or motifs, threads, wool, hessian, raffia – the list is endless. Let your imagination run wild as to how these marks can be used. You will gather some ideas to get you started from the Landscape interpretations section (see page 70).

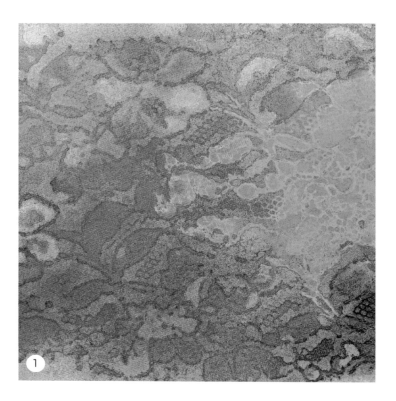

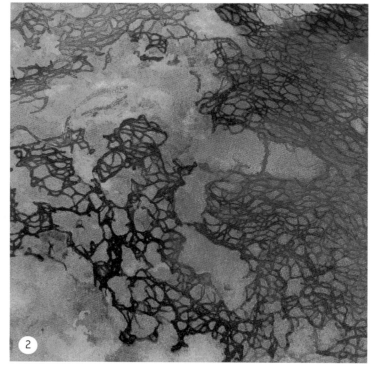

3

4

1 Create decorative textures by placing different kinds of lace into wet washes of colour. In this example I used a combination of translucent and opaque paints soaked into an old net curtain. You could also try using strips of lace, hand-made lace, or individual motifs.

2 There are many different types of net and open-weave fabrics available to buy by the metre or keep your eyes open for second-hand clothes to rip up. Experiment with tearing and distressing them to create a more natural effect.

3 Cheesecloth, scrim or hessian are all made from loosely woven threads, which can be pulled out, moved apart or distorted, as shown here, to create random patterns.

4 Sheer stocking fabric, torn and stretched to create holes and ladders, formed this unusual, almost cellular pattern. The darkest marks are where the colour soaked into the fabric then printed back on to the paper.

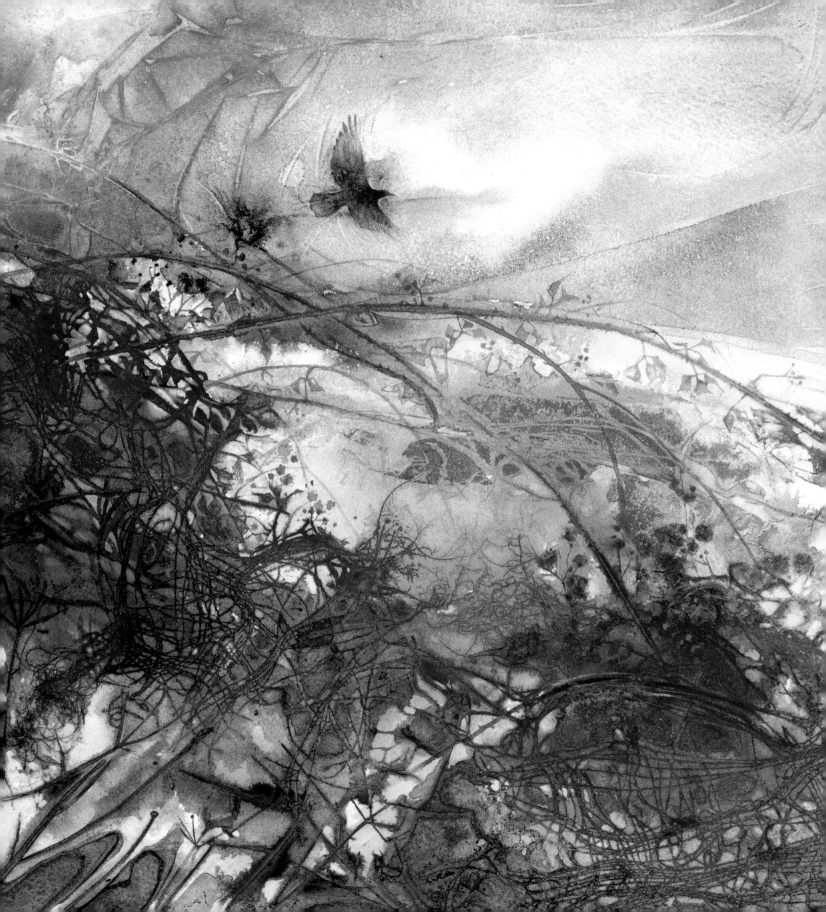

Integrating printed marks

When you play with printmaking techniques using found objects or textured materials, you will find that the results can sometimes be surprising. This means that you need to be flexible in your approach to how you proceed. If you try too hard to control the 'happenings', you may compromise the excitement of the finished result. I have certainly discovered that paintings can be spoilt if I interfere too early. When you peel away the cellophane, found objects and fabrics, don't leap straight into the next stage. Take time to look and ponder. Enjoy the fabulous marks and textures, letting these take precedence over any compulsive need to tidy up or force it into being a particular subject. Prop the picture somewhere prominent so that you can view it over a period of time. If you are disappointed with the results, never simply fling the work into the bin: turn it upside down or view it in the mirror and look again for ways to move forward. You may decide to leave the work as an abstract interpretation, but if you want to develop it into a more representational landscape, you will have to work into it.

In pale, plain areas you can work on top in the normal way, but you may need to use opaque mediums such as gouache or oil pastel to calm down or paint out busy areas, marks or textures that are too heavy or in the wrong place, adding and subtracting to create a composition. You could also develop it using some of the collage techniques described on pages 52–55.

◀ Out of the Woven Hedgerow
41 x 35 cm (16 x 13¾ in.)
I made textures using fabric scrim, dried stems and grasses with ink and watercolour. I placed clingfilm over the plainest area and cellophane over the rest. When this was dry, I decided that the lower part could more or less represent a hedgerow if I simply added a few dots of oil pastel to suggest blackberries and used a rigger brush to paint in some arched brambles and leaves. The bird was drawn in with watercolour pencil and smudged to create movement.

▼ Leafy Carpet
27 x 19 cm (10½ x 7½ in.)
This piece was made as a preliminary experiment in the planning of a larger picture. I liked what had happened and so worked into it as a decorative, semi-abstract still life using gouache to develop some of the more indistinct shapes. I filled in some of the paler markings of the leaf prints with gold paint.

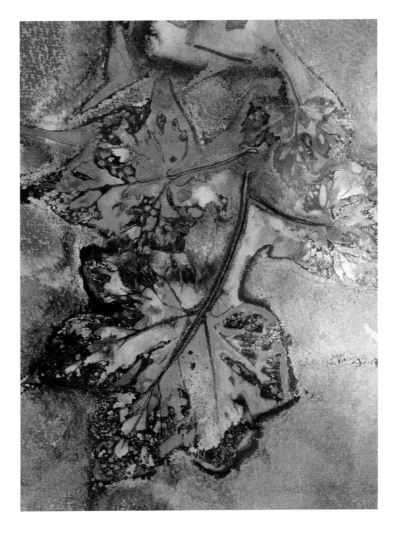

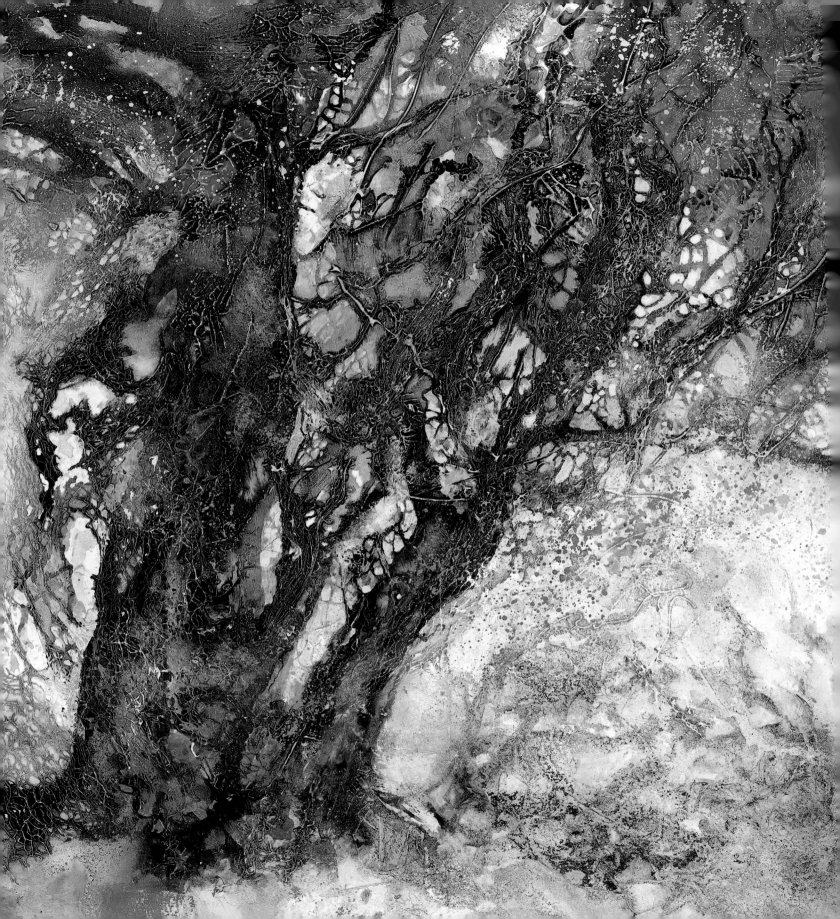

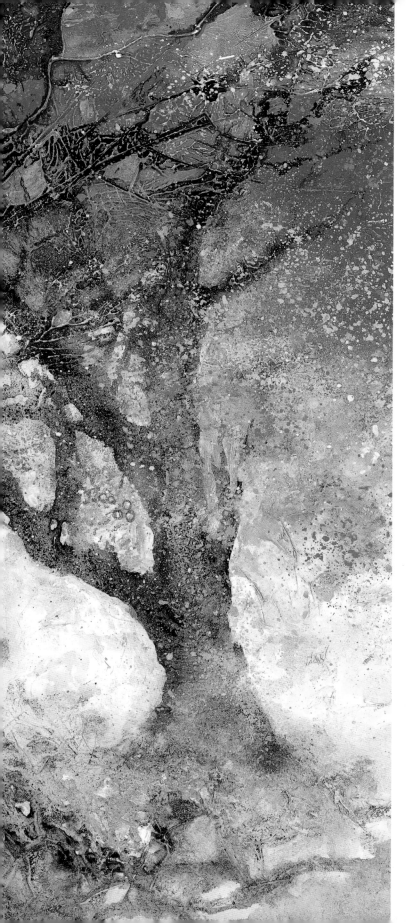

Surface texture and collage

This chapter explores the process of reworking, transforming or enhancing a picture by adding, subtracting and changing it to form an evocative cohesive whole. Make your paintings tactile by adding texture with gesso and other materials. Choose to wipe this away or add natural ingredients gleaned from the landscape. Create new pieces or work over old experiments. Recycle and reconstruct your paintings into a different or related idea. Use collage to embellish or even conceal. The possibilities are endless – but don't rush into your decisions. You may need to look at your work many times before deciding how to proceed. Remember, your latest piece may have huge potential – upside down!

Lost in the Olive Grove
34 x 49 cm (13$^{1}/_{2}$ x 19$^{1}/_{4}$ in.)

Applying gesso

Gesso is an opaque, acrylic-based, commonly white substance that you use to prime a painting surface. It is most often used in combination with acrylic paints, but I have discovered that the unique textured surfaces that you can build up with this medium by applying it with different tools also make it an interesting surface for other water-based mediums. You can create many textures with the gesso by applying it with different brushes and other tools. You can draw or print into it, apply it in slabs with a palette knife, stipple it or allow coarse brushmarks to show. The possibilities are endless. Each surface that you create will affect the layers of paint you apply on top when it is dry, so choose methods that echo the character of your subject. If you want to cover the entire surface of your painting in gesso textures, I suggest that you use the back of a piece of mounting board as it is sturdy. This material would also be the best choice if you intend to add a lot of heavy collage ingredients to the gesso. The paintings in this book only have gesso on selected areas and have been painted on heavy watercolour paper. This way, you get the best of both worlds, combining flowing watercolour on the unadulterated paper with fascinating surface areas.

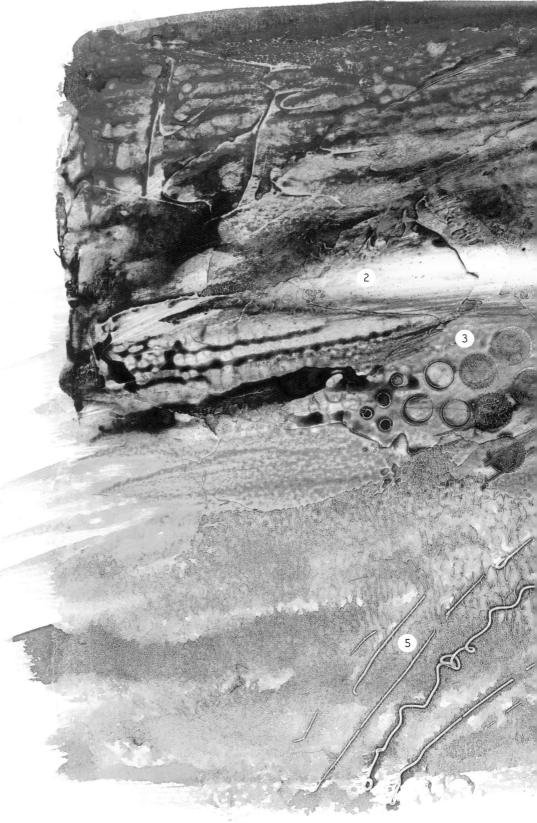

Applying gesso

In this sample, I used a palette knife, house painter's brush or coarse hog's hair brush, and a roller to apply or work into gesso. The work was made on watercolour paper and painted over when dry.

1 Apply a thick layer of gesso with a palette knife and comb through it while it is still damp.

2 You can easily wipe away colour with a damp cloth and reveal the white gesso underneath. This can be done even after the paint has dried. It can be left white or repainted as required.

3 Print into thick areas of gesso. I used paint tube lids here. Notice how the watercolour has sunk into the holes, leaving dark rings.

4 Apply gesso thickly, place cartridge paper on top and peel it away to create a feathered effect. Oil pastel highlights the raised texture.

5 Apply thin strands of gesso with an icing nozzle. You could try using different nozzle shapes for a variety of effects.

Adding ingredients to gesso

You can add ingredients to gesso to create three-dimensional textures. I usually paint thick gesso on first, then press the chosen additions into it or sprinkle them on top, making sure they are well stuck on. My personal choice is to cover and seal this with another layer of gesso, as I prefer the added material to act as an integrated surface texture rather than make its own visual statement. It is especially satisfying to gather elements from the very landscape you are painting and incorporate these into the work – for example sheep's wool, feathers, sand from the beach, grit gathered off a mountain path, lavender or seeds from the field, and so on. For more decorative interpretations, use tactile man-made substances or materials such as embossed wallpaper, fabrics or lace. Become a magpie collector and let your imagination run riot with this treasure trove. Everything you gathered to help create the two-dimensional visual textures on previous pages can also be physically used, in conjuction with gesso, to build up three-dimensional textures.

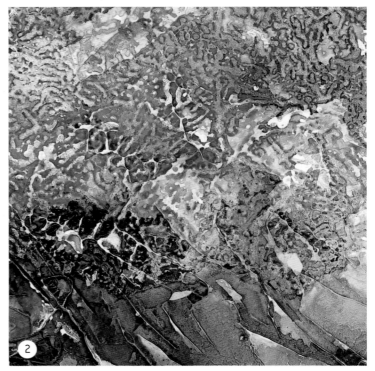

1 Use gesso to firmly stick down crumpled tissue paper. Make sure the crumples are not too big as this would create a vulnerable surface for the paint layer. Seal the top with more gesso and sprinkle on sand for further texture. When this is dry you can paint over it and allow the watercolour to gather around the paper ridges and grains of sand.

2 Use gesso or PVA glue to stick on pieces of embossed wallpaper. This can be sealed with gesso and painted when it has dried. You can emphasize the raised areas by rubbing contrasting paint over them using your fingertip.

3 Grit, tiny shells and shredded fabric make interesting textures. Let your imagination run riot when choosing materials to use.

4 Lace motifs stuck to gesso create unusual stylized representations of flowers in the landscape. Use patterned lace to represent architectural or decorative features. I usually seal these with further gesso and paint over them later.

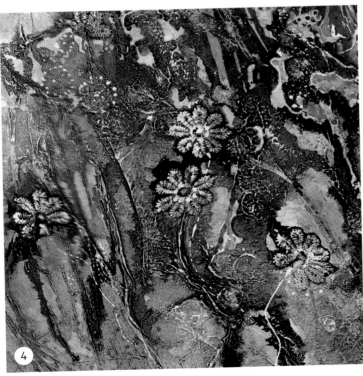

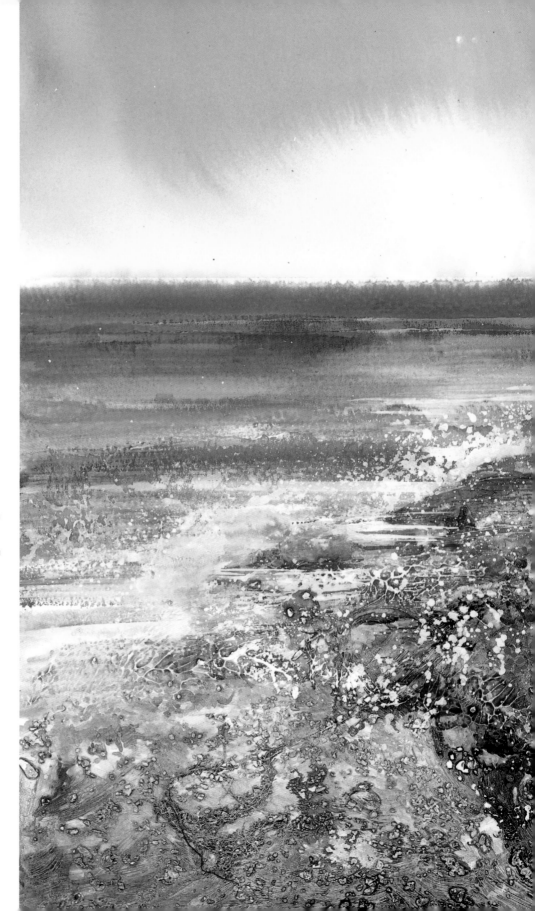

Watercolour on gesso

There are three main stages to working with gesso. The first is the application of gesso with or without any added materials. Be quite loose in your approach to this stage and treat it as if you were using paint. Leave everything to dry before proceeding.

Step two is painting over the prepared base. Different brands of gesso vary and some are more absorbent than others when dry. Normally, the waterproof surface means that it will slightly resist diluted watercolour, resulting in an uneven marbling. You can use this as an effect in itself, or use the paint more thickly than usual for better coverage. Usually, a second layer blends more easily.

The third step is working the paint. Because it has been applied to a waterproof surface, it is easily removed. You can wipe away large areas or skate over raised textures with a damp cloth to create highlights. You can also rub over the ridges to emphasize them, using dry paint straight from the tube, or use a drawing medium such as crayon or oil pastel on its side. If you want to rework an area, you can add more gesso and start the process again.

Rocky Beach
38 x 56 cm (15 x 22 in.)
This was painted on watercolour paper, leaving most of the sky untouched by gesso to retain the loose flow of watercolour. The rest of the paper is covered in a variety of texture-making ingredients to represent the beach and rocks. These include sand, grit, shells, ripped fabric, threads and embossed wallpaper. These were all sealed with gesso and then painted on top.

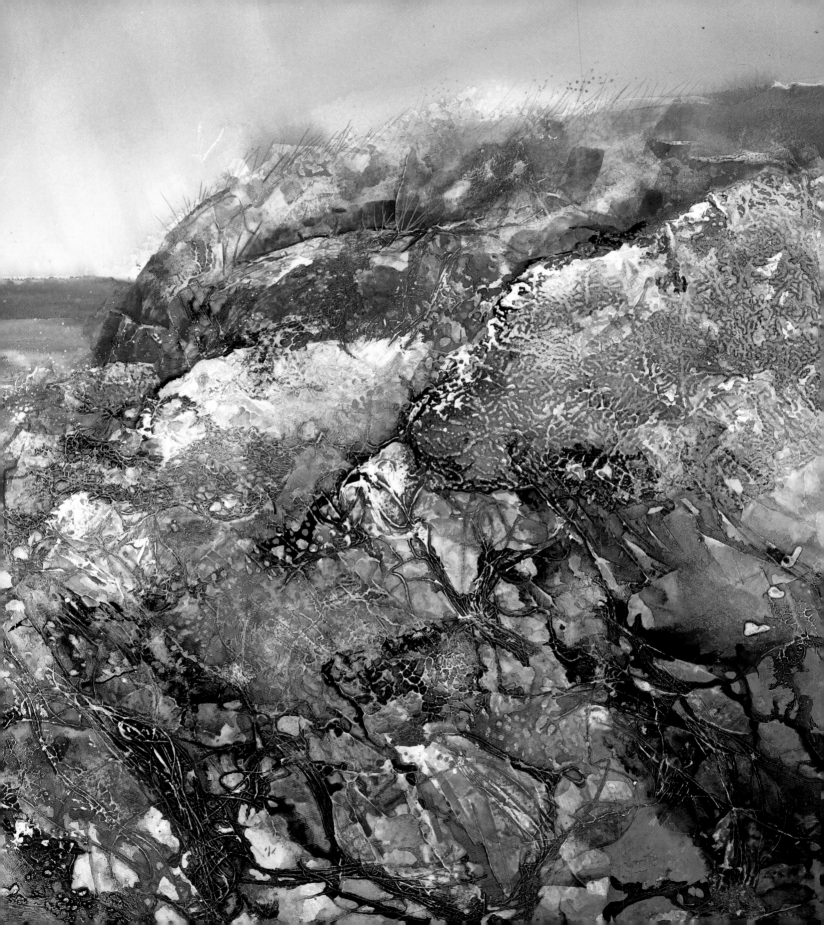

Reconstructing your painting

Throughout this book I have tried to demonstrate that watercolour is not just a one-way process. Many of the methods discussed give you the choice of changing the direction of a painting as you progress. A radical option for transforming a painting is to tear or cut it up and reconstruct it. You might simply change one part of the picture, or the entire design could be moved around. Pieces from different versions of the same subject could be glued together or you could stick new pieces of torn watercolour paper on top of your work and repaint. This last idea is best employed for subjects such as foreground rocks, where the torn edges of the collaged pieces can represent the shape of the subject itself. In this way, you can build up a representational image in a rough and tactile fashion.

The paintings shown here have been torn and reassembled in order to create abstract, fractured designs. You can eliminate and select elements until only the very best parts and essence of the picture remain. I also like the idea that you can hint at several moments in time or create a more multilayered, dreamlike interpretation. The juxtaposition of shapes, colours and textures with glimpses of reality creates a visual poem for onlookers to interpret. Reconstructing a painting is a form of collage and you can extend this idea much further by adding other materials.

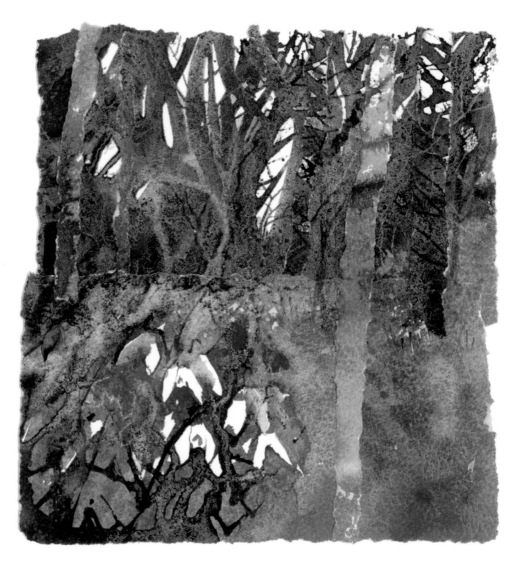

▲ Snowdrops in the Wood
19 x 17 cm (7¹/₂ x 6³/₄ in.)

After painting a watercolour of some snowdrops in a wood, I decided it needed extra layers of interest. I tore away the straight edges, and then tore it across the horizon. The two pieces were repositioned and overlapped; I slightly misaligned them as I stuck them on to a new piece of paper. I glued some of the discarded strips from around the edges on top of this to represent trees.

▶ In My Dreams
39 x 37 cm (15¹/₂ x 14¹/₂ in.)

I combined elements from several related paintings, piecing them together like a patchwork and feeling my way towards an image. Every positioning of texture, tone and colour was carefully considered before sticking each piece down. I used PVA glue to reassemble these on another heavyweight sheet of watercolour paper.

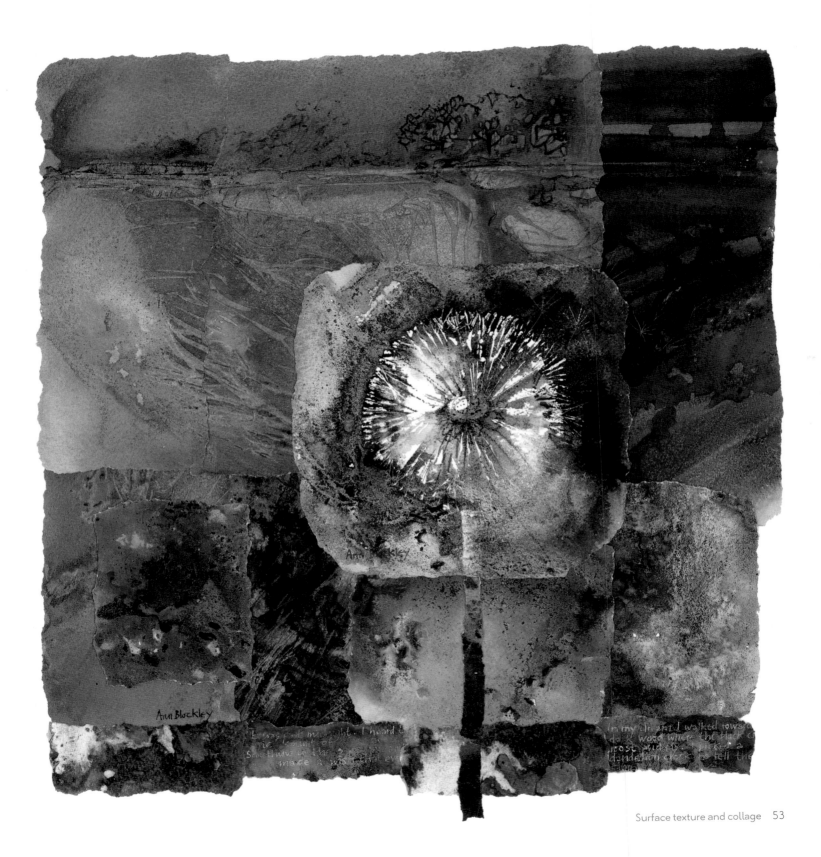

Collage

There are entire books dedicated to collage, so all I want to highlight here is how collage can relate to watercolour, either as a base or an embellishment, to move ordinary paintings forward into something more unusual. There are infinite opportunities for exploration, so I am simply going to list some possibilities to whet your appetite.

It is a personal decision as to whether or not you worry over the archival properties of your chosen materials. My own choice is to only use lightfast materials. If I am not sure whether a printed material is lightfast, I will photocopy it using good-quality, lightfast printing ink and use that instead. Use PVA glue or acrylic medium to stick down your collage materials. The latter is best if you are going to add wet paint on top as it is more waterproof, but the PVA may cope better with sticking materials that are heavy or absorbent.

Collecting and choosing materials

Here are some ideas for collage materials.

- Recycle your old watercolours. Add collage to them or find sections within them to save as collage pieces. Cut out shapes or tear them into organic shapes. Punch holes in them and use the punched-out circles.
- Buy handmade papers such as Japanese rice paper, marbled, mulberry, bark, or lokta papers. These are available in specialist craft shops or from Internet retailers.
- Paint your own papers using the techniques described earlier. Colour white tissue or translucent papers with watercolour or ink.
- Save printed ephemera: local or foreign newspapers, magazine cuttings, sheet music, old documents and letters, and tickets.
- Print out your own photographs on different kinds of paper in colour or black and white. Photocopy objects or materials.

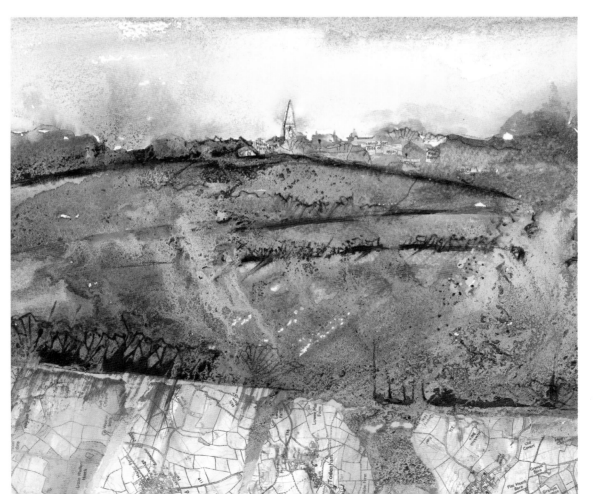

On the Map
20 x 25 cm (8 x 10 in.)
I photocopied a map of my village and used torn pieces as a partial collaged base on watercolour paper. I enjoyed cutting squares from the map containing words such as 'Farm' and sticking them in the correct position within the painting. I painted over this base and added extra bits later to balance the picture.

Heat and Dust
20 x 25 cm (8 x 10 in.)
This was painted on a base of sand and gesso, with scraps of paper printed with relevant words.

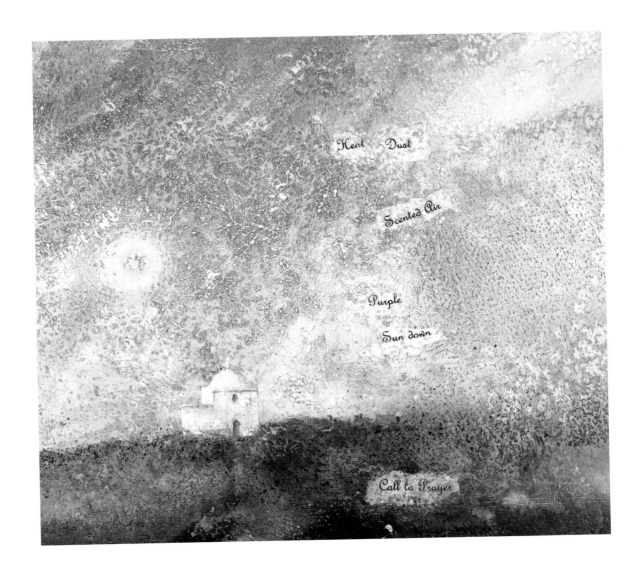

Using collage

I use collage in quite a selective way, choosing to limit what I include to a simple base or embellishment. My aim is to let the watercolour itself be the prominent feature. However, the options are there to build complex designs using multiple and varied collage layers.

Collage can be used to create a range of styles, from the abstract to representational. You could create an abstract pattern out of collage materials and use this as a background on which to build a realistic picture. Alternatively, you could begin by collaging a photograph and then working in a representational way on top, allowing elements of the first image to shine through. You could opt for a surreal effect, where the combination of images does not quite make sense, or use photographs that are relevant to your subject. If you prefer a less whimsical approach, you can mimic the physical appearance of a scene by collaging many snippets of coloured or textured papers on to a ground, as if applying slabs of paint.

If you stick images such as buildings or animals on top of a background, you can integrate them into the picture with more drawing or paint. Another option is to use bits of collaged material to add highlights of colour, physical texture or extra meaning. Choose things that are relevant to the landscape you are interpreting, such as a local newspaper, map, music or poem written about the place. Use adverts and tickets in townscapes, dried flowers and feathers for country scenes.

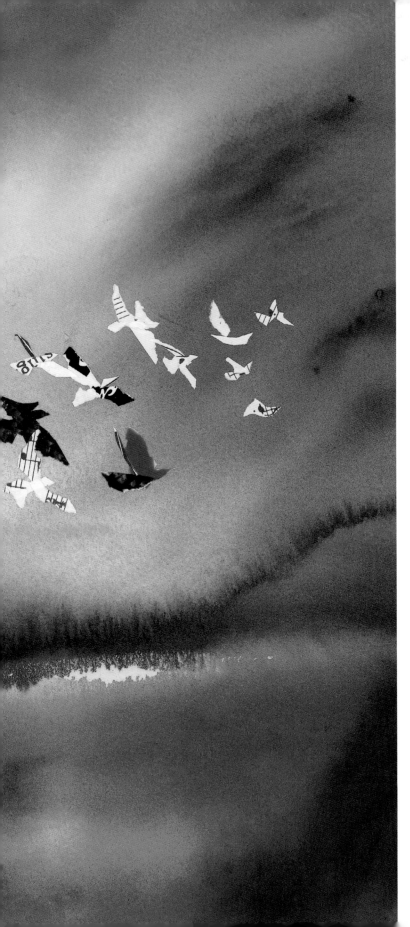

Creative thinking

Forget rigid rules and labels, conservative parameters, stifling traditions and conforming to the norm. Dare to be different. Put aside preconceived ideas of how things 'should' look. Be curious and nurture your childish, creative soul through adventure and play. Explore with drawing, doodling and photography. Listen, taste, smell and feel as well as using your eyes, but above all keep your mind open and follow your instincts. This should help you to identify exactly what pushes your buttons and give you something special to say in your watercolours. Feeling alive and in tune with nature will help you to interpret it visually.

When Birds Do Sing
30 x 40 cm (12 x 15¾ in.)
I photocopied some music from an old-fashioned piano music book I used as a child, selecting a song called 'When Birds Do Sing'. I tore tiny pieces of the music into flying bird shapes and stuck them in a flock over a loose watercolour of land and sky.

Gathering ideas and information

If your paintings are to make a clear statement, you need to be connected with your subject. Sketching on site helps to forge this link. It forces you to be selective and distil information into what is meaningful to you. In transferring this data to a painting, further selections will be made and the result should be an intensely personal interpretation. Colour can be added literally or through verbal notes. My own preference is to sketch with paint rather than using line. The fact that you have visited a place and absorbed its atmosphere is more important than your choice of materials or technique. A doodle with some descriptive words may be all that is needed as a reminder. Notes such as 'Indigo clouds echo shapes of treetops' or 'Cacophony of rooks swirling home to roost' may suggest more to you later than a detailed drawing.

Photography clearly has a place in this digital age, where we have so much to do and so little time. However, if I have not spent enough time in front of a subject, I feel disconnected when painting it later. Without an instinctive gut reaction, it can easily become a superficial manufacturing act. The process of making a sketch is not just about what goes on paper – it is an experience in which we absorb all sorts of information such as smells, sounds, the weather, insects and animals scurrying past, a bonfire being lit or a field being ploughed. All these external, sometimes non-visual elements, add to the richness of the experience and help influence later painting decisions.

A collection of paint sketches and natural objects

My guilty secret is that I am an obsessive hoarder and wherever I go, I pick up nature's treasures. When you gather shells, leaf skeletons, feathers, seed pods and bits of bark they will act as visual and tactile reminders of a landscape and help keep you strongly connected to the essence and atmosphere of a place.

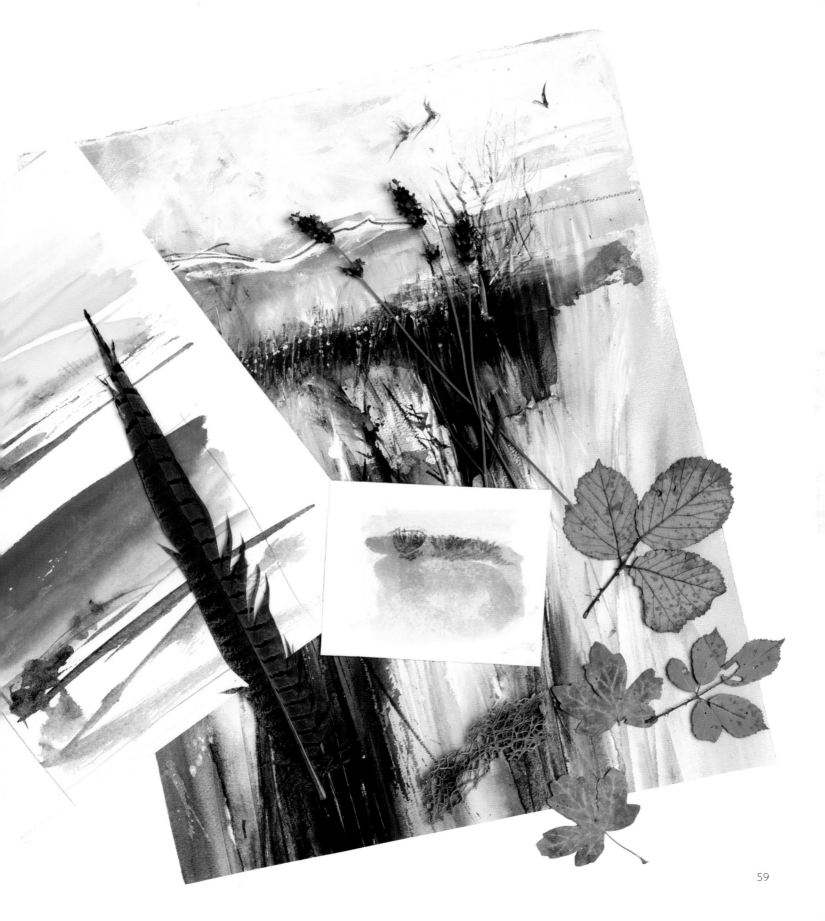

Feeding your imagination

Sketchbooks and photographs are useful for recording what you see and I suggest that you always carry at least a tiny notebook or visual diary. This will keep the creative juices flowing and help you to be alert to your surroundings. Another useful habit is to keep an 'inspirational' scrapbook in which you save painterly 'treasures'. Stick in wonderful scraps demonstrating technique or colour and label them with suggestions for landscape use, such as 'Ploughed field' or 'Snowy sky'. Include cropped sections from unsuccessful paintings, poems, magazine clippings, rubbings of textures and collage material. If you go through a stagnant phase using watercolour, you could experiment with landscape interpretations using another art form such as collagraph, image transfer or monoprint. All these can be put in the scrapbook. Creativity is a hungry beast and needs to be fed and nurtured! Exploring and treasuring ideas helps to keep you in tune with yourself and feed your imagination, so that painting ideas flow and grow.

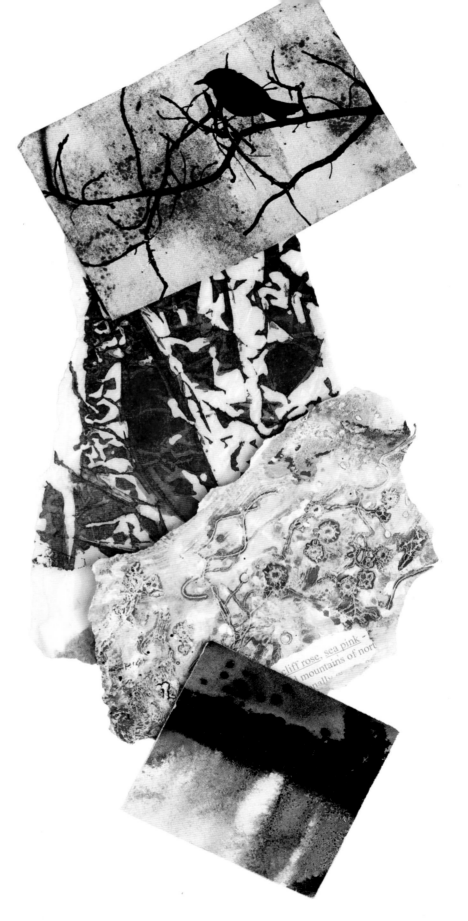

A collection of paint experiments, scraps and prints

The paintings that stand out from the crowd are the ones where the artist has a very personal connection to the subject. This is what I advocate and want to encourage everyone to develop. It is important to identify exactly what really does 'push your buttons', so that you have something special to say in your paintings.

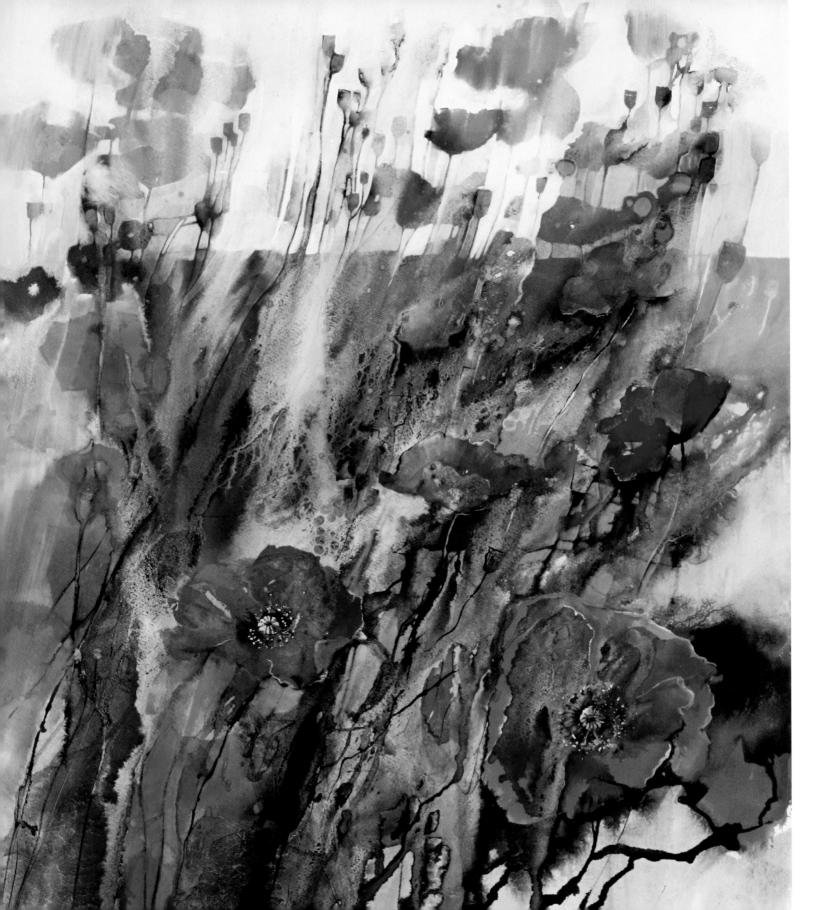

▶ Colour experiment

I dislike absolutes and rules, but I find this one essential: always experiment and play with colours before you begin a painting. By this, I mean filling a piece of paper with proper washes and not small, paint-chart dabs. Not only will this assist you with decision-making, but it will help you to loosen up.

Creative colour

I love nature and its evolving kaleidoscope of colour. In England where I live, the colours lean towards cool because of the northern light. Travelling has opened my eyes to the way your palette needs to change to match different climates and the fact that nature sometimes needs a helping hand, wherever you are. Landscapes on a dull day can be uninspiring, however spectacular the terrain. Repetitive green and monotonous brown is not a recipe to make our hearts sing. You have to use imagination, not only to change the temperature and tones of colour but to create different moods: drama, tranquillity or mystery. Try to avoid the monotonous colour stereotypes often found in landscapes. It is not just a case of straining to see hidden nuances of colour: you need to be inventive.

If you find this difficult, try the following idea. Rather than inventing a totally new colour scheme, look for small accents within a scene and use these as a starting point for adjusting the overall view. For example, a rusty red roof on a distant barn could inspire you to add related shades of this colour elsewhere in the picture. Perhaps the sky could be changed to a pale mottled orange that echoes the roof. Flashes of russet may replace or liven up an uninteresting green field. If you do not want to falsify the colour in front of you, exaggerate and heighten what already exists instead. Experiment with many shades and variations of hue rather than using one pigment to describe each subject, and use accents of complementary colour to add interest. Try and make a distinct personal statement, whether this is a shout or a whisper.

Here is a list of the watercolours I use most. For simplicity, I have based all these on Winsor & Newton names, although I do mix and match brands: French ultramarine, cobalt blue, cerulean blue, cobalt turquoise, lemon yellow, Indian yellow, cadmium orange, cobalt violet, quinacridone magenta, quinacridone gold, brown madder, cadmium red, Winsor red, perylene maroon, raw umber, green gold, burnt sienna and indigo.

◀ Poppy Dance
74 x 55 cm (29 x 21¹/₂ in.)

Real poppy fields tend to be green and red. These colours can make a striking statement, but I feel that my interpretation is more original. The swaying poppies are dancing in party frock hues of purples, pinks, magenta and scarlet. The seed heads have been transformed out of mundane green suits into outfits of blue, turquoise, pink and golden brown. The usually verdant field has become a fantasy backdrop of mauve and blues.

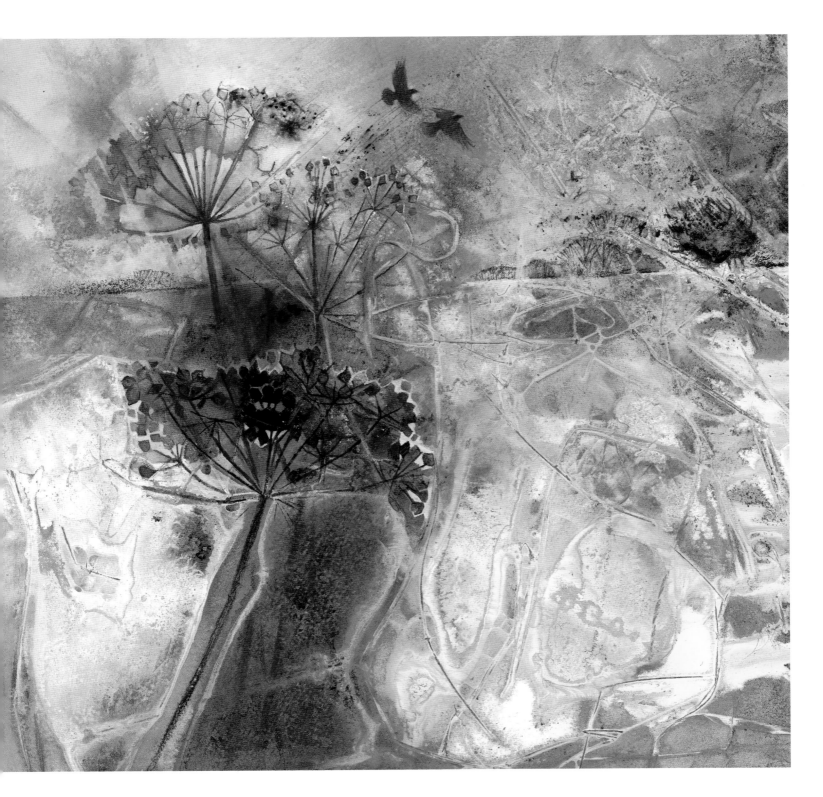

Composition

There is a lot to consider when composing a painting. An easy way to simplify matters is to use a basic rule of thirds. If you imagine dividing your picture into nine equal sections and use this mental grid to place significant areas and subjects, you will generally ensure a pleasing composition. For example, shapes such as land, sea or sky can occupy the lower or upper third, and features and landmarks can be positioned on the intersections of this imaginary framework. Once you are comfortable with this idea, you can experiment to create more adventurous compositions.

It is not necessary to fill every fraction of a composition in order to create an interesting picture. Leave room for your subjects to breathe, and balance busy textured areas with plainer space or simple, flowing watercolour. Planning a composition is like drawing a map using visual pathways and arrows to plot a route. Create trails of marks or colour to direct the eye or use the diagonals and verticals of subjects like grasses, branches or posts to point towards the next feature.

You need to be selective to make strong, successful images, so it can be useful to crop your work. This does not imply a kind of failure: I see it as the extension of a creative selection process. To help you see if these choices are necessary, cut two corners out of an old mount and move them around your painting to find new, more interesting compositions.

After the Harvest
34 x 34 cm (13½ x 13½ in.)
The largest illustration shows my almost complete painting. I felt it needed something to link the sides and considered adding another bird. Before deciding, I looked at these other cropped options. One idea was to cut the picture vertically and mount the two sections in separate windows within one frame. Another was to trim it to just the seed head. If I chose the latter version I would also make some small compositions from the remainder of the picture and use them for collage.

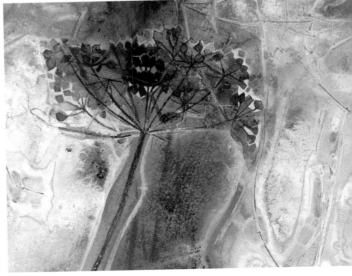

Towards abstraction

Abstraction indicates a departure from reality. This deviation from accurate representation can be partial or complete. An abstract work may transcend the logic of perspective and indeed may bear no trace of any reference to anything recognizable.

Expressionist painters presented the world through the subjective emotions and responses that a subject evoked. They distorted and exaggerated the drawing and colour, and explored the paint surface in order to express these moods or ideas. I like to work using elements of these ideas. Many of my current paintings lean towards the abstract. There is still an element of something recognizable – they contain glimpses of reality without relying on a pedantic excess of information. The idea, with this style, is to hint at a subject but stay elusive and suggestive. It is similar to the difference between poetry and prose.

Each of the pieces illustrated here contains a personal meaning that an onlooker can only understand fully through my verbal explanation. You will draw your own conclusion from a completely abstract painting according to your own experiences and mood, regardless of the artist's intention. Therefore it is even more essential, in this style of work, to create beautiful imagery that resonates and speaks for itself through the language of paint.

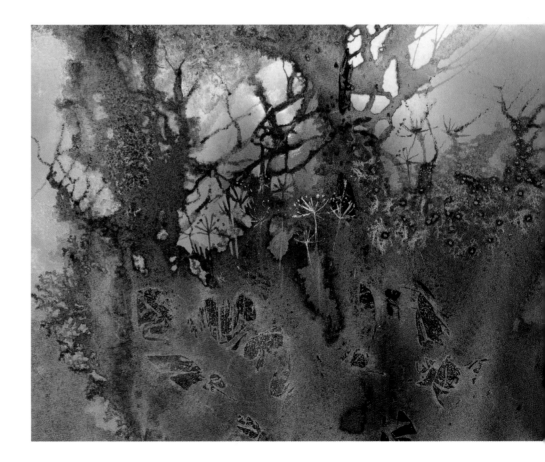

Hedgerow Tangles
15 x 18 cm (6 x 7 in.)

Is this piece abstract? I see it so clearly as a tangled hedge that I find it hard to judge. It began as a loosening-up exercise using phthalo turquoise, indigo and burnt sienna. I allowed the wet paint to dribble and meander into a complex web of marks. As soon as I added the more precisely drawn hogweed shapes, the abstract meanderings gained context and meaning.

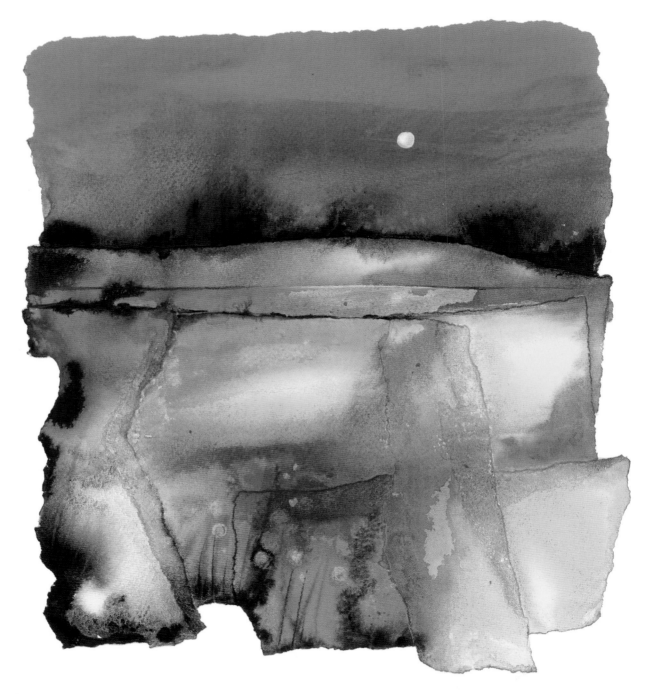

Field Patchwork
30 x 26 cm (12 x 10¼ in.)

In order to abstract a country view of evening fields into a rustic-looking patchwork, I decided to paint on an unusual layered surface of geometric shapes, pieced together to echo and hint at the subject. I glued torn pieces of watercolour paper together, overlapping them into an interesting design. I ripped some of the paper to reveal strips of the more absorbent inner layer. Inks and watercolour sank into the edges of the paper strata, emphasizing the pattern.

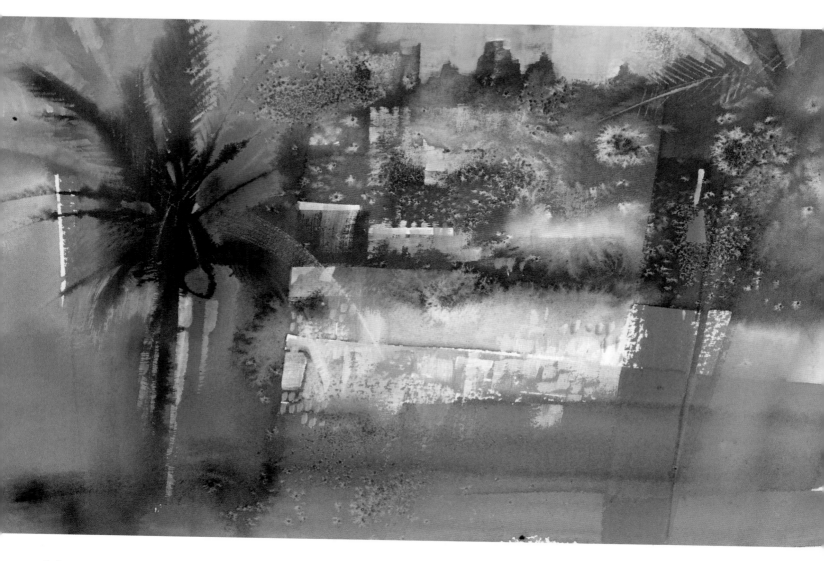

Moroccan Mirage
20 x 28 cm (8 x 11 in.)

During a trip to Morocco I spent time viewing and absorbing the atmosphere of this ancient hilltop casbah, glimpsed through an oasis of palm trees. I did not paint it at the time, feeling stifled by the thought of making a prosaic interpretation of a single view. Morocco offers such intense imagery: crumbling walls, intricate patterns, and the colour of souks and silks. I wanted to synthesize some of these overlapping thoughts and experiences in my picture. Removed from the scene, I was able to relax and work subconsciously, allowing the information I had stored – both visual and emotional – to work its way into this watercolour translation.

Instinct and intuition

Eastern Promise
18 x 30 cm (7 x 12 in.)

'I am on a small boat, speeding towards a tiny Thai island. The sun is an intense disc of concentrated colour. Light still shimmers on the tangled mangroves but the shadows are calling.'

I wrote these words in a holiday diary, and this image reminds me of them. I created it by painting rich layers of watercolour, including a blob of undiluted paint. I covered this with cartridge paper, which I rubbed and then lifted away, leaving printed feathered markings. It is easy to be cynical about giving meaning to such an image, but I am a firm believer in the truths that serendipity and the subconscious can reveal.

To make your work more expressive and abstract, you need to try and turn off the practical left side of your brain and tune into the intuitive and creative right side. Welcome childish thoughts and unusual ideas. Abstract interpretations are not always logical, so dismiss that negative inner voice that whispers in your ear about how *not* to paint. Try not to think too hard at all and rely on instinct and intuition as to what *feels* right. It can help if you listen to music while you work; turn off your phone and avoid checking your e-mail in order to 'switch off'. You need to be flexible and relaxed, both mentally and physically, in order to loosen up your painting and interpretative skills.

Many painters find it difficult to let go of purely visual, photographic interpretations of a scene, however much they would like to. Sometimes it helps to paint a series of a similar subject. Once you get the realistic information out of your system and you are familiar with a subject, you can afford to let go and focus on feelings and expression. I suggest at this point that you put all reference material away, especially photographs, and work from memory. This will help you to concentrate on the abstract aspects that are truly important to you. If you enjoy painting *en plein air*, you could treat your outdoor work as information gathering and paint a more abstract interpretation when you are removed from the actual scene.

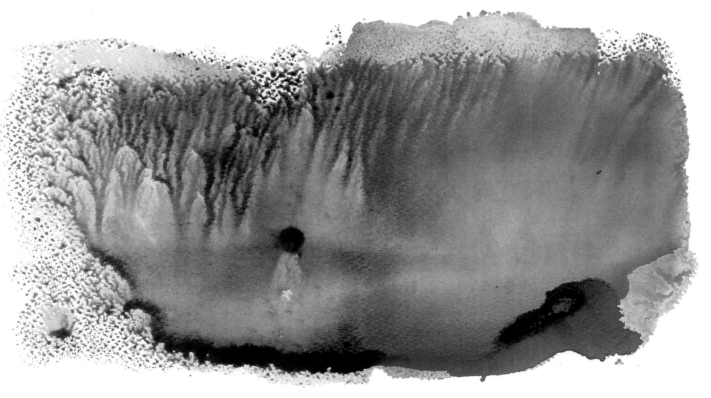

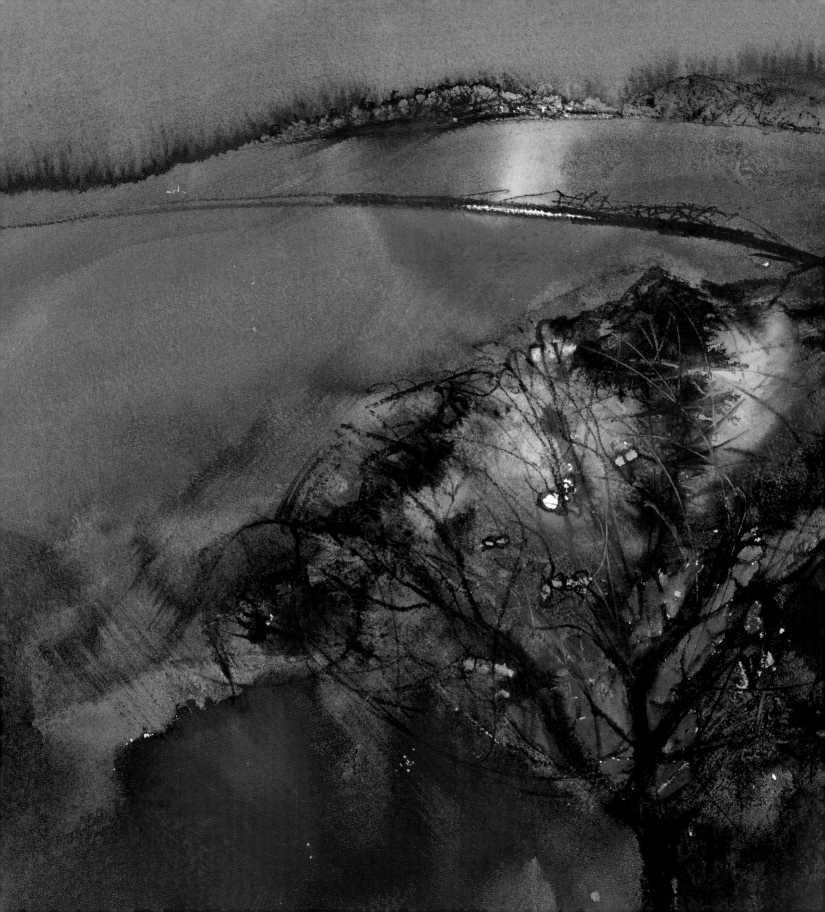

Landscape interpretations

I am showing you some landscape interpretations to give you examples of where you might use the techniques discussed in earlier chapters. These subjects are all meaningful to me because they are places I have visited or subjects close to home that I see throughout the seasons in different guises. I expect that you have your own landscapes to interpret and experiences to record. In order to give you an insight into how you might make your own decisions I have described some of the thinking behind each of the following paintings. This might be something about the place, my mood or atmosphere, the weather or why I chose certain colours or methods. The important bit is the choices that you will now make!

Landscape in Blue and Red
33 x 44 cm (13 x 17¼ in.)

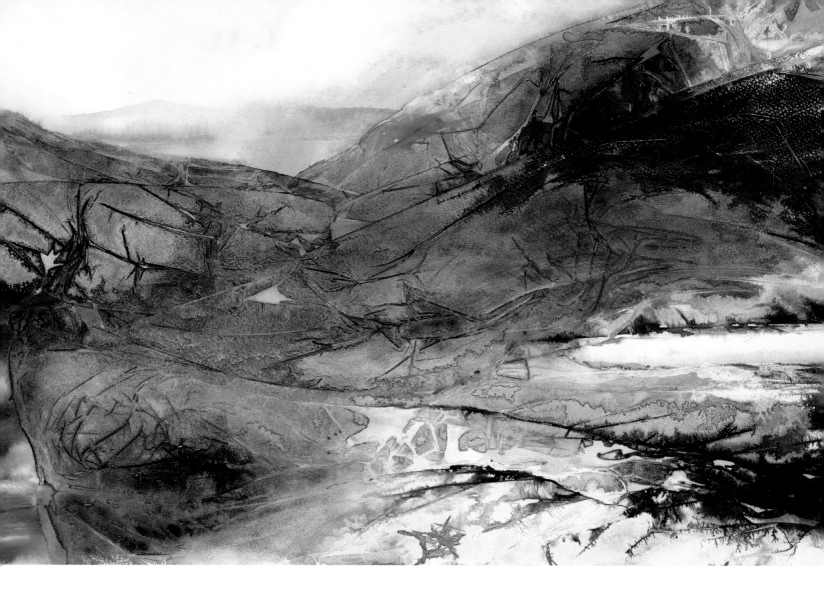

Climb Every Mountain
32 x 43 cm (12¹/₂ x 17 in.)

I am a northern lass at heart and am drawn to the wild, open places that my family visited as I grew up. In Scotland one November, I trekked through this barren but beautiful mountain landscape. The ground crunched underfoot where the boggy ground was frosted with crackling ice. To capture a sense of this, I painted washes of watercolour over the whole paper. I painted the sky and distant hill simply and plainly, but covered much of the rest in layers of clingfilm placed to describe the interlocking shapes of the mountainside. I dribbled sepia ink under the clingfilm to travel along the creases. This emphasized the directions of slopes and folds in the terrain. It also felt appropriate for the hard-edged fracturing of the icy earth.

Icy Mountain Tarn

35 x 48 cm (13³/₄ x 19 in.)

When you are walking through landscapes, the composition of the scenery constantly changes. This painting shows a different view to *Climb Every Mountain*, with the foreground more separate from the peaks. To show this difference, I used granulation medium to add gentle texture to the mountains, and used graphic crumpled clingfilm effects only in the flatter areas. The light cast sparkles on frozen mosaics of shattered ice within a series of small tarns; I used white ink under clingfilm to indicate these. I lightened the sky using white gouache, quite thickly scrumbled over a dry watercolour wash. This also helped to emphasize the prominent shapes of the mountain summits.

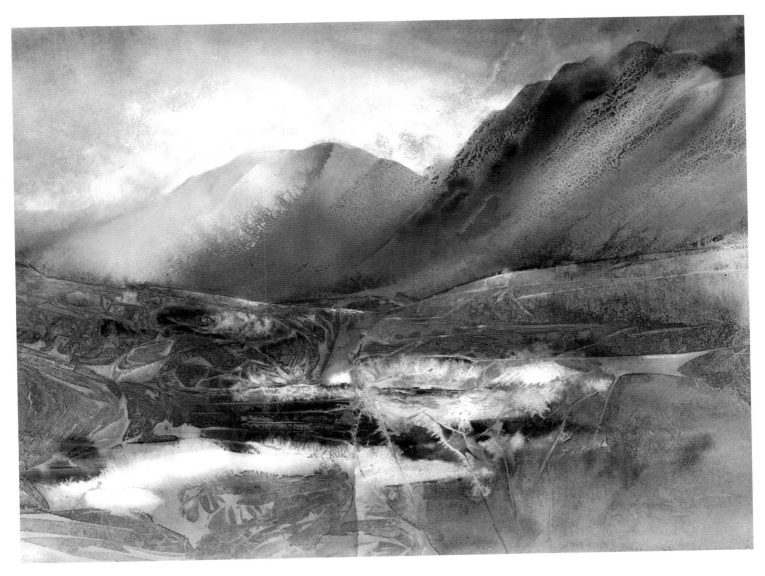

Come Rain or Shine
23 x 31 cm (9 x 12¼ in.)

It is incredible how the weather can transform a landscape and often so quickly. One minute the sky is a flat wash of blue, the next moment clouds are racing across, creating ragged patterns or veils of mist that disguise and soften the silhouettes of distant hills. As an artist, I love days like this and dread clear blue skies! Angry clouds and windy weather demand gutsy, confident washes and marks. Painting on the spot means working quickly to keep up with the weather, but even if you are indoors a scene like this can be interpreted with vigour. Scrub on your paint, then scribble and slash lines through it with courage. There is no time for namby-pamby shadings and fuss: it might start to rain!

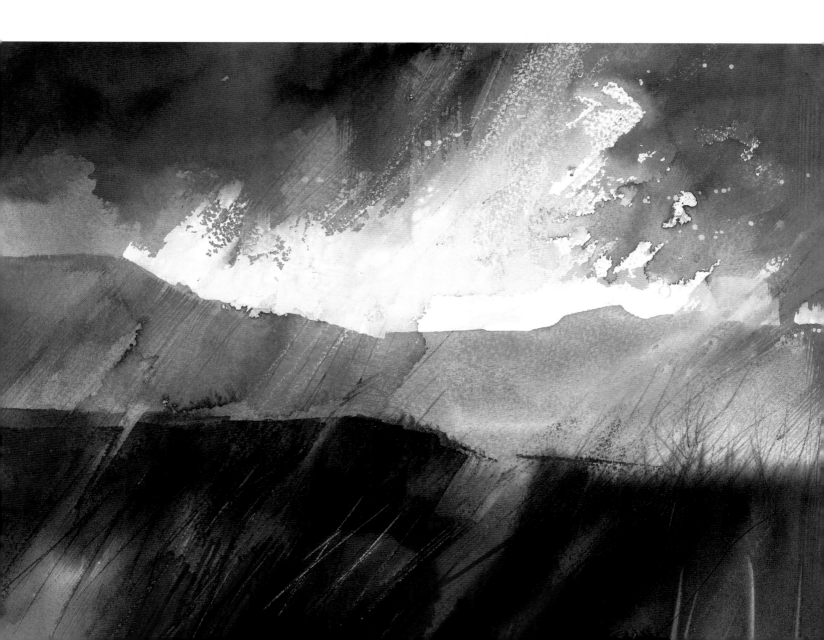

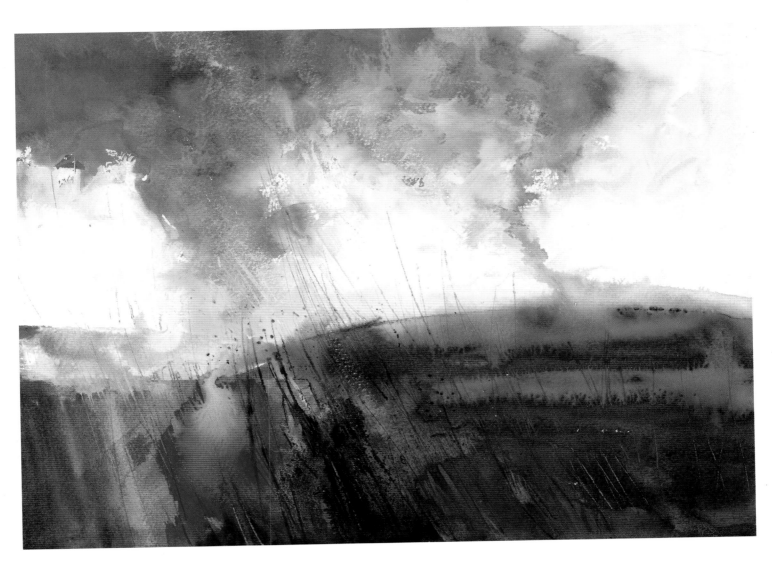

In the Pink
26 x 35 cm (10¼ x 13¾ in.)

Landscapes are not static. Clouds scurry or shift, sunlight flickers, grasses sway and insects scuttle or flit. To get a sense of movement in this painting of fields and sky, I painted very loosely and let messy things happen – like back-runs, unblended markings and rough edges. I drew swiftly through washes of colour using a grey watercolour pencil in a diagonal direction, to follow the swaying motion of grasses and link them with the sky.

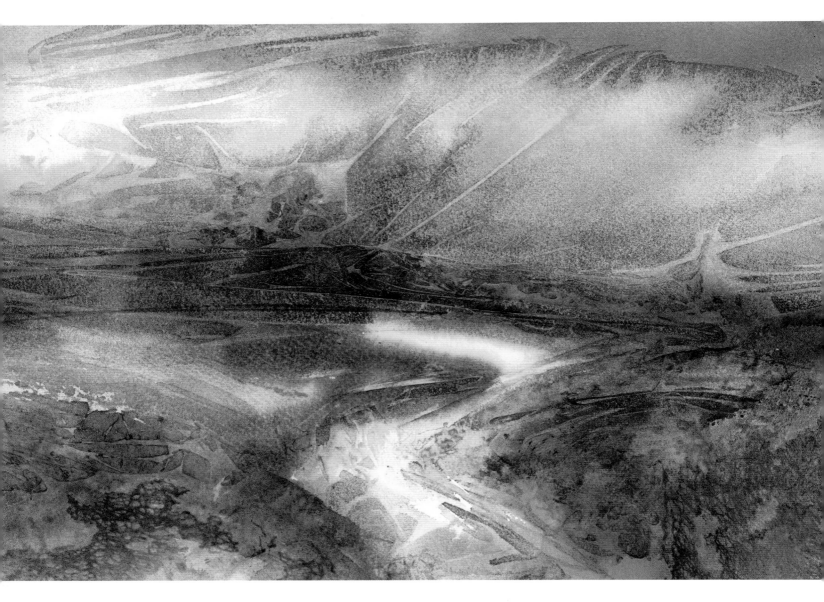

Off the Beaten Track
30 x 40 cm (12 x 15¾ in.)

There were many little trails leading through the misty moor in Derbyshire, and as I was on my own, I began to feel a little anxious about getting lost as the sun went down. In this version, I made the sky the most interesting feature using clingfilm to add shapes and pattern. The effect was not true to life, but it seemed to echo the zigzag twisting of the pathway. This was also treated to some clingfilm texture, but I left the wet-into-wet wash untouched where it disappears into the distance. This area shines out from the rest of the picture, drawing the eye towards the mysteries of where the track may lead.

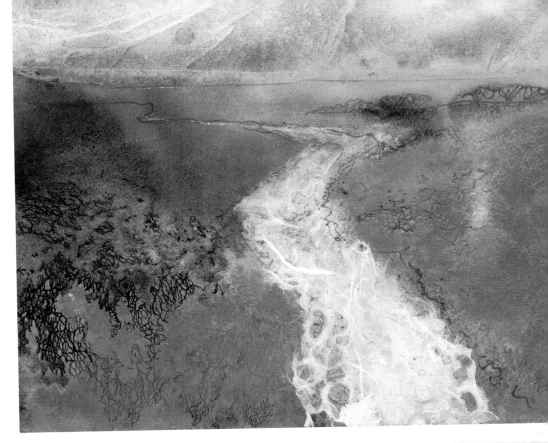

▶ The Road Less Travelled
26 x 30 cm (10¼ x 12 in.)

This interpretation of the Derbyshire moors was painted using similar techniques to the other versions, with the addition of some collage. Pieces of torn Japanese lace paper, bought from a craft shop, were frayed at the edges and stuck with acrylic matt gel on top of the initial wash to make a pathway. I like the way the random holes in the unusual paper create an impression of rounded stones or cobbles. The translucent paper allows the wash underneath to partly show through, which helps to integrate the collage with the background.

▶ On the Right Track
26 x 38 cm (10¼ x 15 in.)

On a trip to Derbyshire, I walked through some heather-covered moors. The gently undulating land was swathed in mauve and pink, and the early evening sky changed hue as I walked the tracks between the hummocks of closely knit plants. In this interpretation I made the distant trees the same colour scheme as the rest of the picture, rather than using the green tones of the real scene. I felt that this added to the atmosphere. I used some torn, net-like fabric to imprint its pattern into washes of colour and act as a rough representation of the textures of the heather. The path was left as a very pale wash and a light sprinkling of salt gave a faint mottled impression of pebbles.

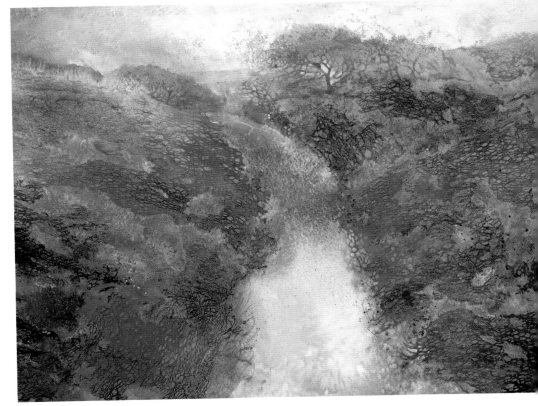

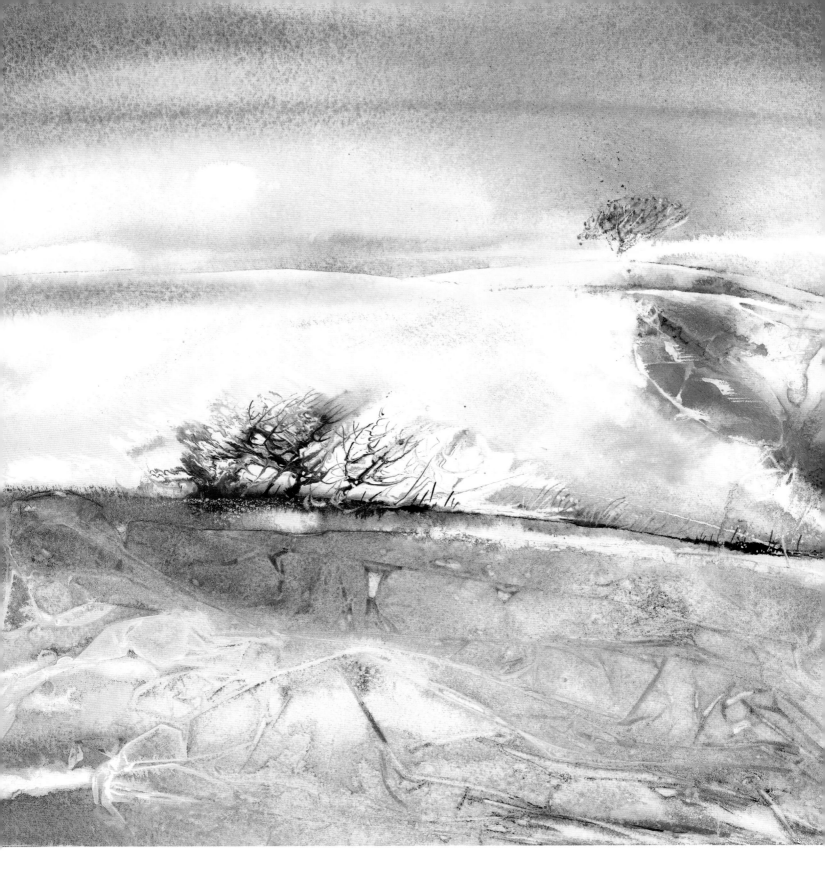

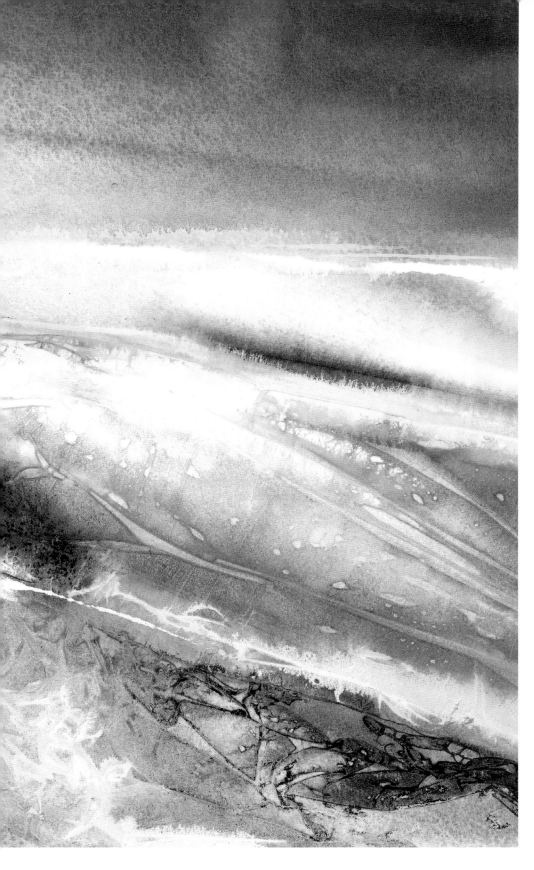

Shadows in the Snow
28 x 44 cm (11 x 17¼ in.)

I chose a very white paper for this snowscape, leaving some areas untouched by watercolour. I dampened the paper and drifted in pale washes of cobalt blue and cobalt violet to describe shadows and the contours of the land. I think of these as being ice-cream colours, although I must admit that I have never seen blue ice cream! Perhaps that thought occurred because of the mid-ground trees. These have a chocolate ripple effect made by pulling ink through white gouache using a sharp point. This is a similar method to that of making feathered icing on a cake. Clingfilm was crumpled into some of the washes to add a crackly feeling of ice and frost, but I was careful to leave some plain areas to create an atmosphere of distance and solitude.

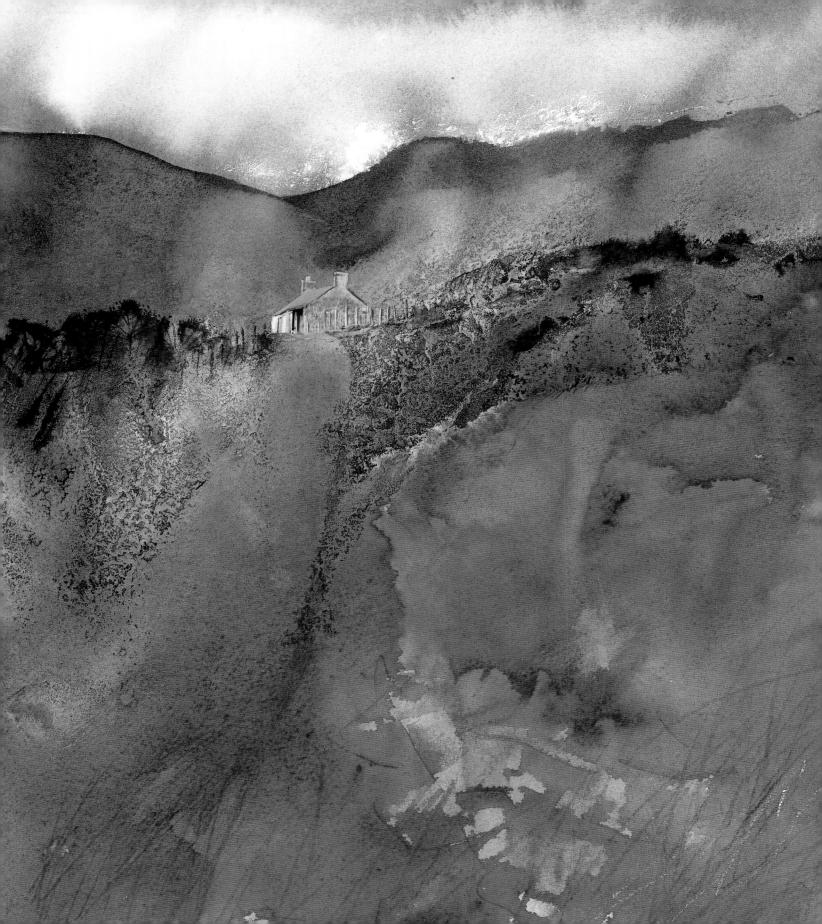

◀ Highland Croft
33 x 29 cm (13 x 11¹/₂ in.)

To create distance in this mountain view, I combined cool indigo in the sky and mountains with warm brown madder in the foreground. A hint of cobalt turquoise draws the eye towards the focal point. I used thicker paint towards the bottom, so that I could scrape through it with chunks of card and make pale rock shapes. I added sepia ink to describe a row of gorse while the watercolour was still wet, and dripped granulation medium into this. Brindled textures spread down the page and formed a pathway. I cut out the shape of a cottage with a rusty tin roof from a photograph I had taken and collaged this into the picture. I then painted over it with gouache, adapting the colours to fit the scene.

▼ Cornish Cottage
19 x 29 cm (7¹/₂ x 11¹/₂ in.)

This was painted on a gesso-covered base. I added sand to build up a gritty surface and created raised feathery effects in the lower right-hand corner by pressing thin paper into the gesso and lifting the paper away. When dry, I covered it all in washes of brown madder, raw umber and sepia, then painted white gouache over the sky. I rubbed away some of the paint in the lower fields with a damp cloth and lightly highlighted the raised textures with opaque colour to suggest a gorse bush.

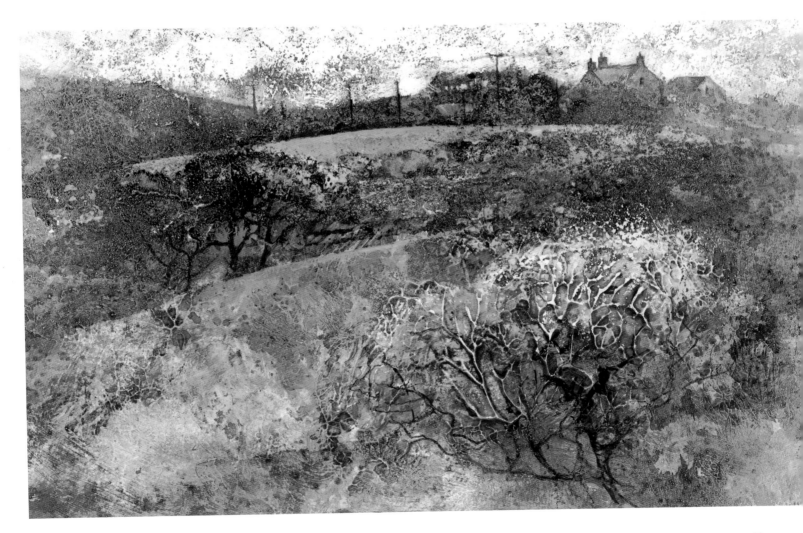

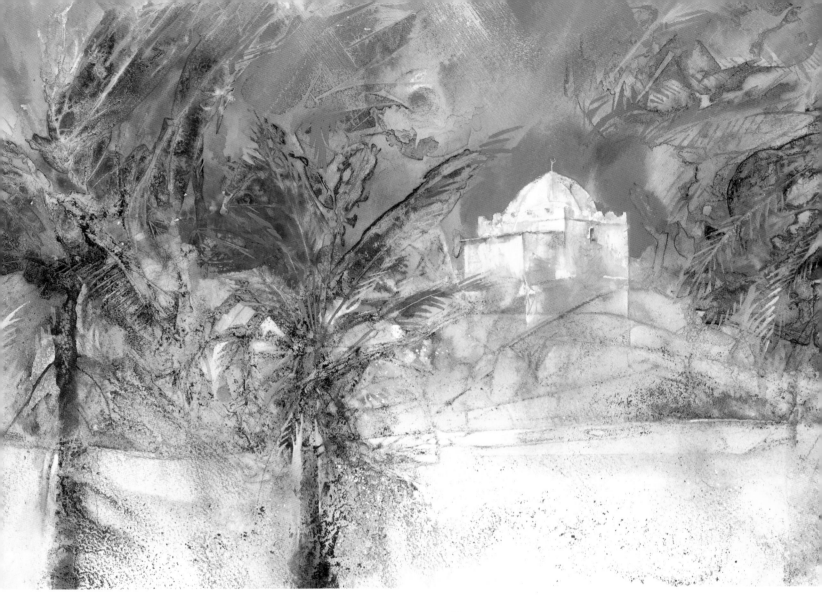

▲ Oasis
30 x 42 cm (12 x 16½ in.)

Driving through beige, sandy scenery in Morocco I was alerted to
this pocket of green. I decided to evoke a dreamlike quality in my
interpretation, as if the scene were a kind of mirage. The decorative
building is perched high on a slope and I let the colours float together.
I intensified the actual colour of the sky to give a greater contrast with
the white building. I used cerulean blue, applied with a flat brush in
criss-crossed directional marks, to echo the shapes of the palm leaves.
I used snippets of clingfilm to break up the palm tree and added
granulation medium in the foreground wash to create a dusty, speckled
atmosphere. Dots of orange oil pastel described the palm fruits and a
smudged circle of gold gouache echoed these as the sun in the sky.

▶ Through the Gate
21 x 19 cm (8¼ x 7½ in.)

This yellow buttercup field shone through gaps in the plants over a gate leading to a church. This is a typical Cotswold summer scene, but to avoid making a painting that was too 'pretty', I abstracted the lower half, with its overlapping stems and gate slats, into a mosaic-like pattern. The main emphasis was the field, which I strengthened with patches of yellow gouache. The upper half of the picture was smudged and made vague using watercolour pencil in damp paint.

Little House in the Landscape (overleaf)
27 x 46 cm (10½ x 18 in.)

I try to keep buildings simple to give a focal point without detracting from the beauty of the surrounding landscape. A plain geometric shape is often all that is needed. The cottage in the landscape overleaf contains minimal detail but you can still identify it.

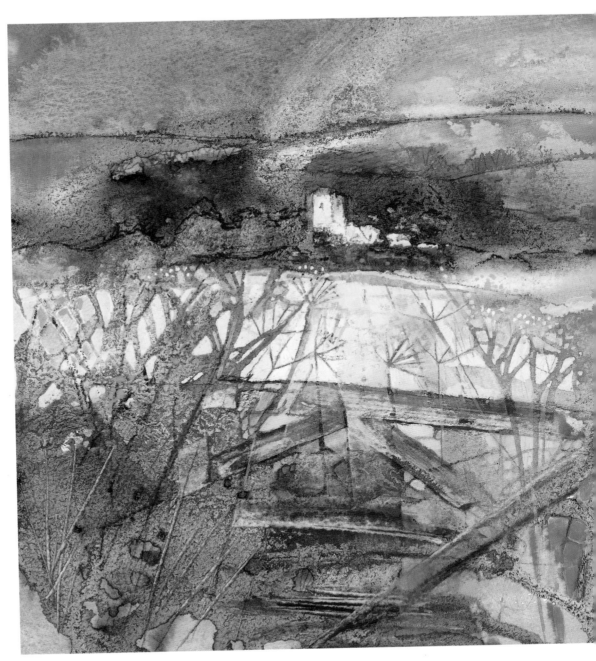

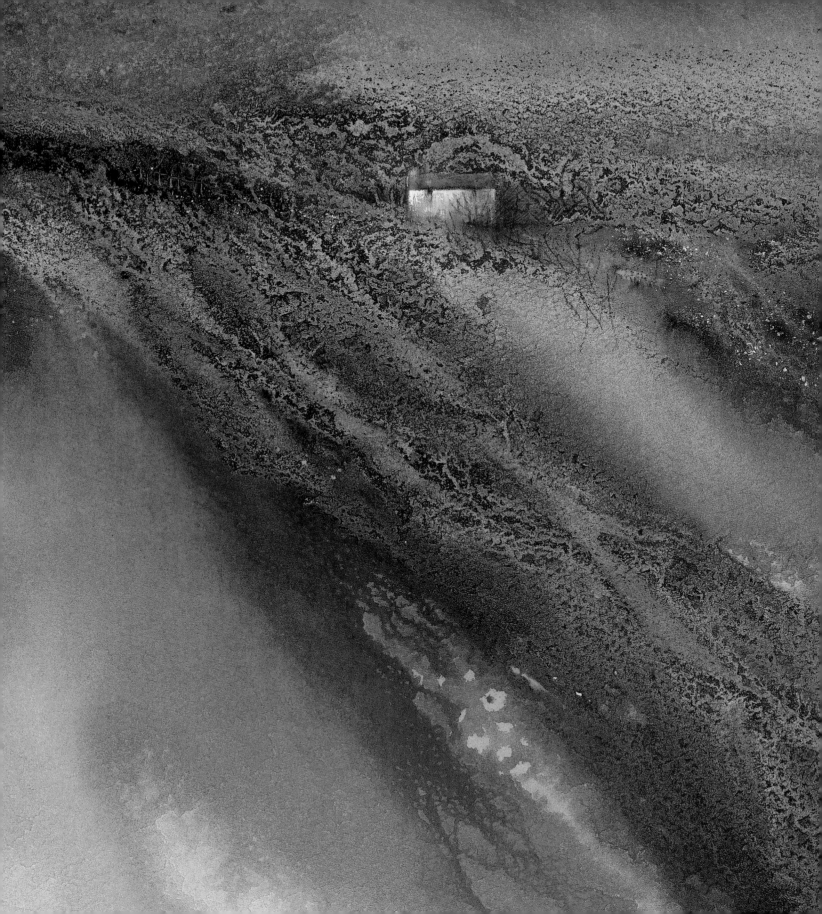

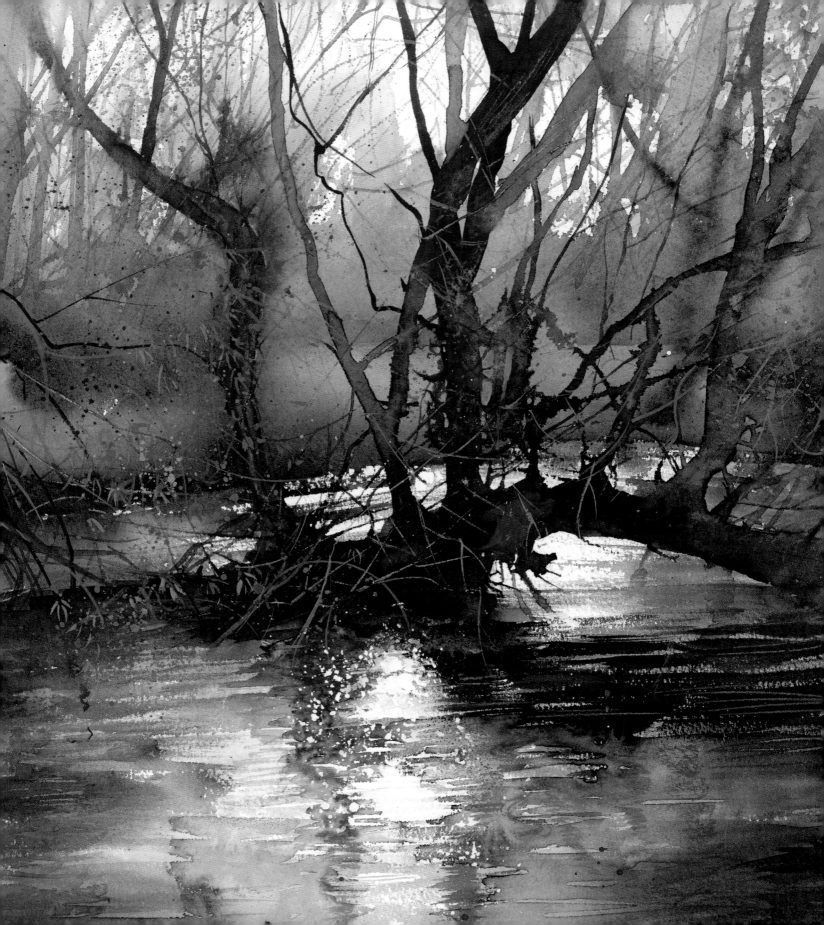

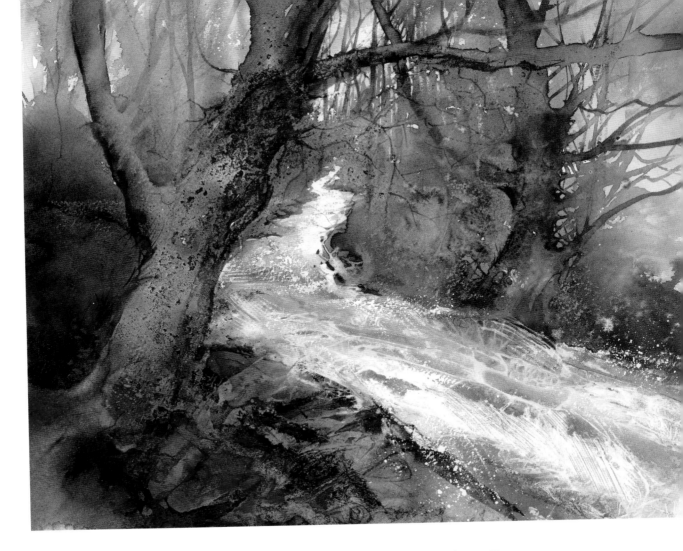

◀ Bridge of Willow
39 x 28 cm (15½ x 11 in.)

To build this picture, I used more traditional steps than I normally take. I painted the background first, with misty washes of cobalt blue warmed with cobalt violet and shaded towards a bank of pthalo blue. I used more sparing horizontal brushstrokes to suggest the water, leaving white paper shining through. The fallen willow was painted while some of the first layer was still damp. In parts it blends with the background, especially where it sits in the water, but elsewhere the shapes stand out as hard-edged. I chose indigo with a touch of perylene maroon for the browner willow branches, using a size 3 rigger brush to describe the meandering shoots. Further horizontal brushstrokes built up the reflections and a spattering of white added the final shimmer.

▲ Rushing River
29 x 34 cm (11½ x 13½ in.)

My main aim here was to create an impression of movement. I can still hear the Welsh mountain stream pounding past me, churning up froths of foam and spraying me with a fine mist of water droplets. Where the stream disappeared into the woods I left it white, gradually introducing a darker wash towards the bottom. I placed clingfilm over the approaching water and poured white ink underneath, tilting the paper in the direction of the rushing river so that the ink flowed through the creases, replicating its movement. When this was dry, I used the tip of a palette knife to speckle sprays of white gouache.

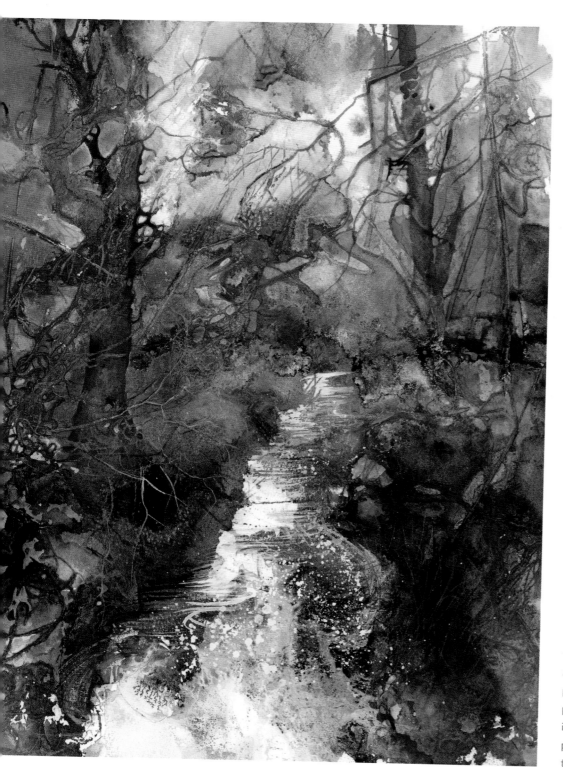

◄ Woodland Stream
39 x 28 cm (15½ x 11 in.)

Having made some fairly traditional interpretations of water, I decided to experiment with putting the river into a more abstract woodland context. I added threads of fabric and bits of dried grass to watercolour washes and left these to dry under a layer of cellophane weighted down with a board. When this was dry, I painted into some of the abstract decorative shapes, turning them into trees. I used white gouache to block out the river reflections and sparkles, and also the light sky showing through the branches.

► Secret Pond
37 x 34 cm (14½ x 13½ in.)

I discovered a secret pond hidden behind fronds of water reed, wild parsnip and willowherb. I wanted to interpret it with an air of mystery, like the setting for an ancient legend. To create my magical playground, I took bits of moss and plant forms from around the pond and used these to make prints under cellophane as described on pages 36–39. This area would be worked into with gouache later, to formulate the pond and bring out the negative shapes of the plants.

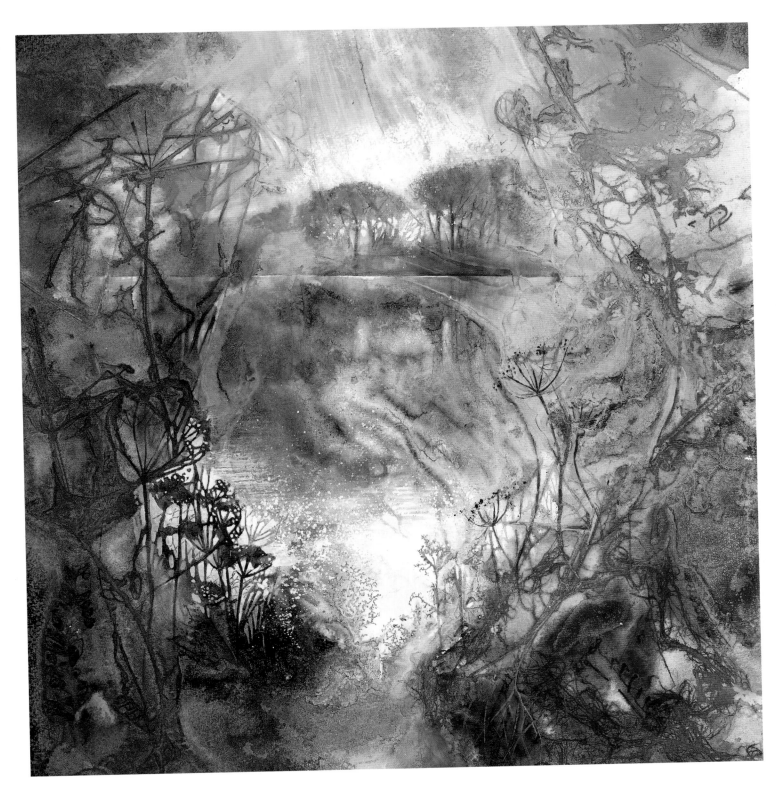

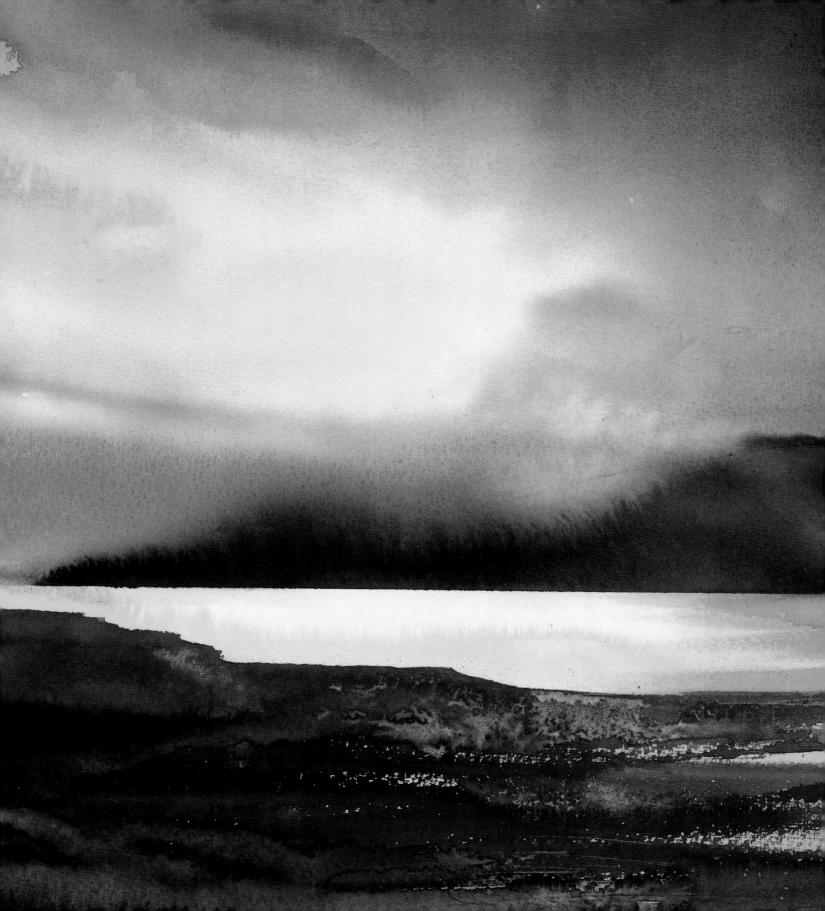

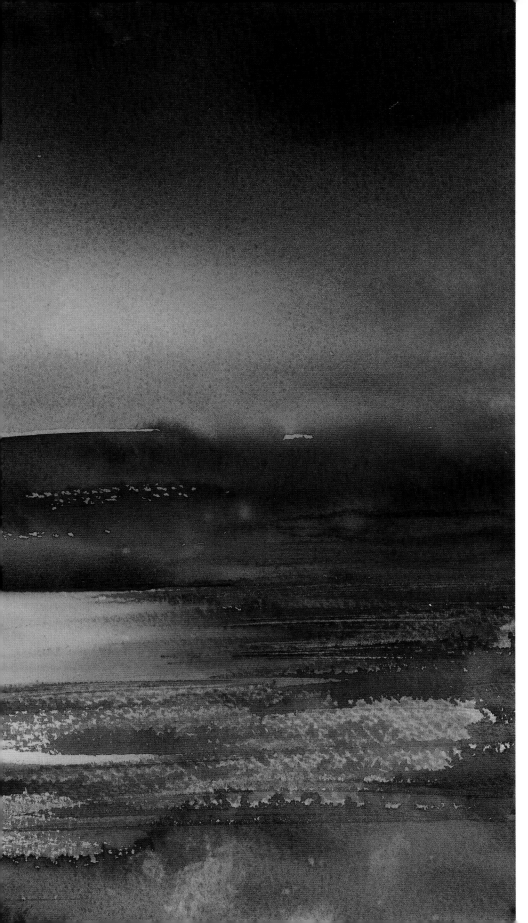

Golden Waters
31 x 43 cm (12¼ x 17 in.)

The west coast of Scotland has some spectacular sunsets. This one reflected on to the water, turning it into a sheet of gold. The clifftops almost disappeared under the haze of light. This painting was all about light, so as a rest from textures, I made a straightforward watercolour painting. Sometimes the simple things work best.

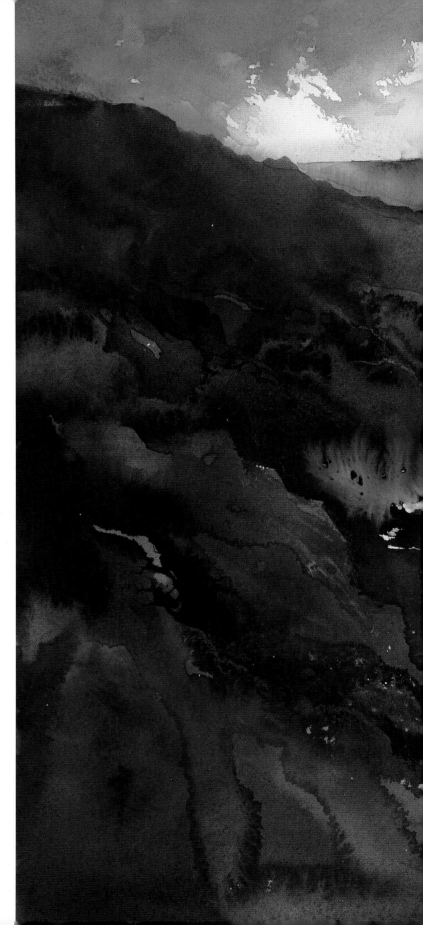

On the Rocks
37 x 48 cm (14 1/2 x 19 in.)
To relieve the blues of this seascape, I injected colour by painting the
rocks in washes of perylene maroon, burnt sienna, indigo and pthalo
blue, varying the dilution between sections. Pools of excess colour
were allowed to flow back into back-runs and blooms. I sprinkled a
little sea salt on to selected rocks to add a barnacled texture. The sea
was applied with horizontal brushstrokes of pthalo blue – sometimes
wet, so that the paint flowed and sometimes dry, to allow the paper
to glitter through. When it was dry, I skated over the surface with
white gouache to increase the sparkle. Splashes of it were shaken
and flicked vigorously from the brush around the rocks.

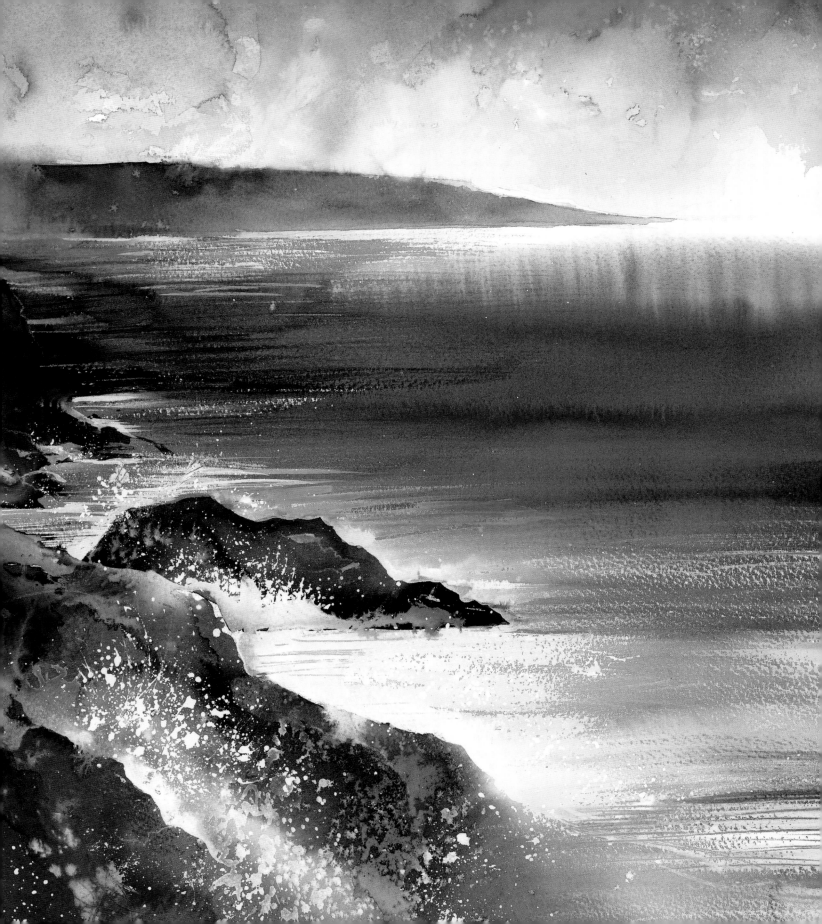

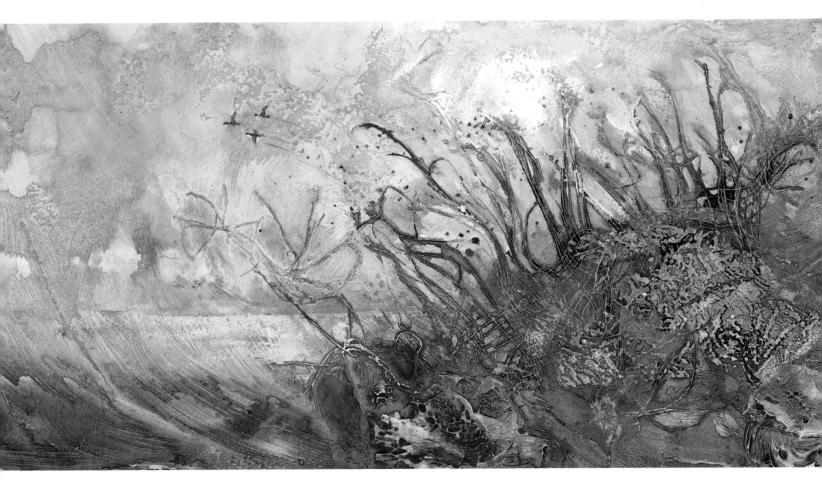

▲ On the Banks of the River
17 x 31 cm (6³/₄ x 12¹/₄ in.)

I applied gesso over watercolour paper using a coarse brush to sweep it across for a
windswept impression. I spread the gesso thinly with a palette knife over the sky and more
thickly in the corner in order to stick collage materials including scraps of embossed
wallpaper and scrim – these would represent the riverbank fringed with grasses. I sealed
them with further gesso. The watercolour created a marbled texture over the prepared
surface of the sky and sank more firmly into the crevices of the collage.

▶ Snail's Pace
44 x 33 cm (17¹/₄ x 13 in.)

I experimented with interpreting a crumbling stone
wall using collage materials primed with gesso to
recreate its tactile textures. I varied the application
of the gesso and used scrim, distressed fabrics and
textured paper. Some tiny lace motifs were used as
a decorative way to represent little flowers. After
painting all this with watercolour, I decided to take
things further. I tore holes and distressed the edges,
letting some of the threads embedded in gesso fray
out like stray grasses. The spiral shapes of the lace
made me think of including a snail to inhabit the
wall, and it amused me to think that the ragged
holes had been made by him!

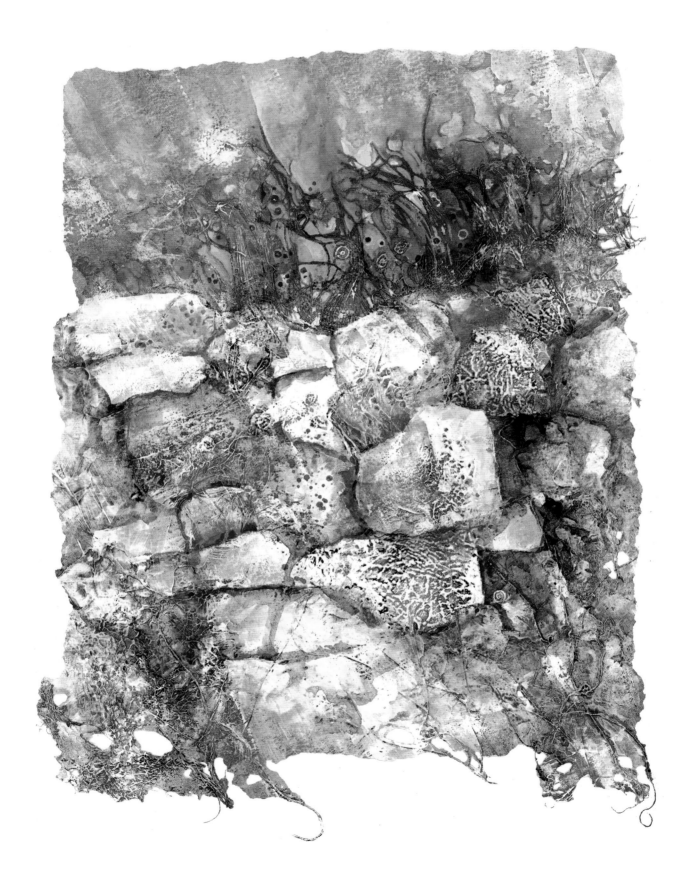

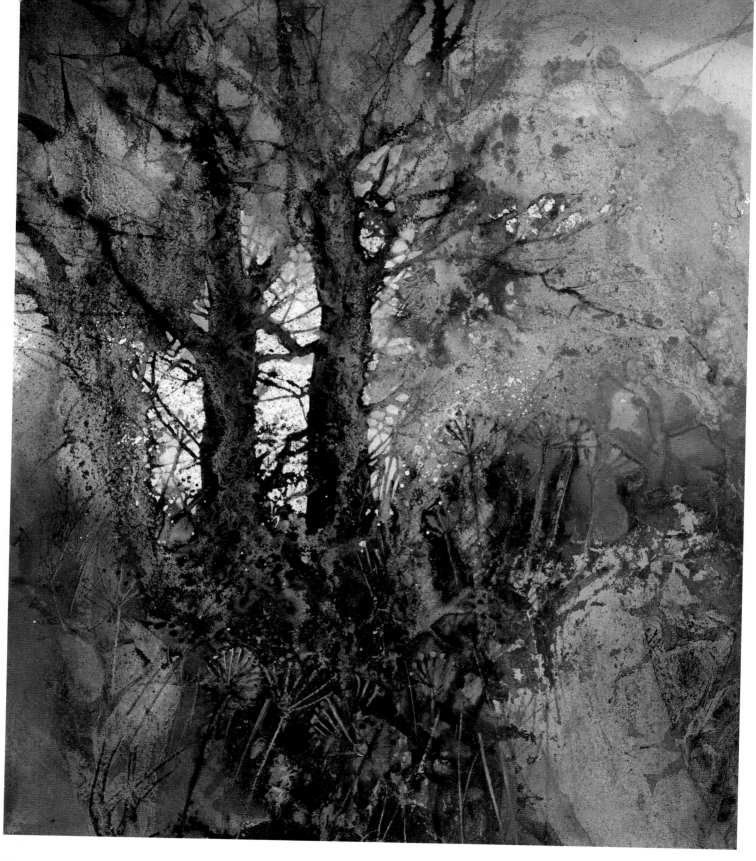

◀ Autumn Gold
30 x 26 cm (12 x 10¼ in.)

I made interpretations of these two trees throughout the seasons. The obvious impact in the autumn version is the rich colour. In real life there were more greens, especially in the ground, but it seemed more atmospheric to gild the whole world in shades of rust and gold. I used brown madder with some burnt sienna for the background and added Indian ink to the tree shapes to form natural granulation textures. I also added a subtle glister to the background wash with gold ink.

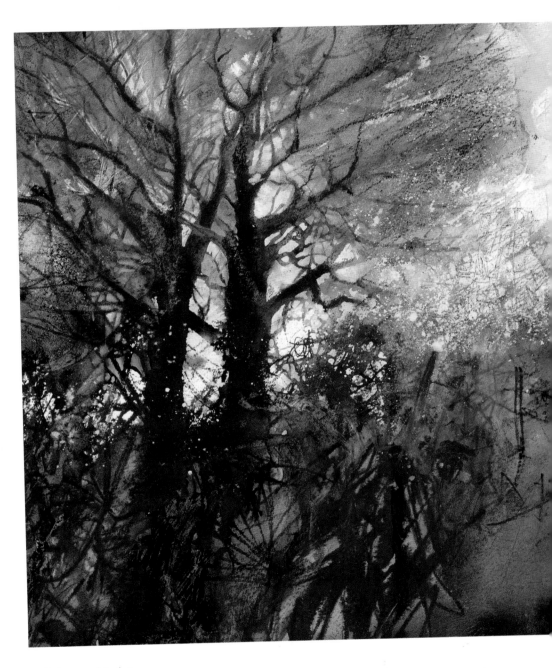

▲ Winter Light
30 x 26 cm (12 x 10¼ in.)

The winter version of these trees is almost monochromatic. I used black Indian ink and sepia ink for the trees and undergrowth, with touches of brown madder in the foreground to add life, and some lemon yellow and quinacridone gold to glimmer through the branches. Watercolour pencils were used to draw extra branches and fence posts, and scribble in some loose foreground information.

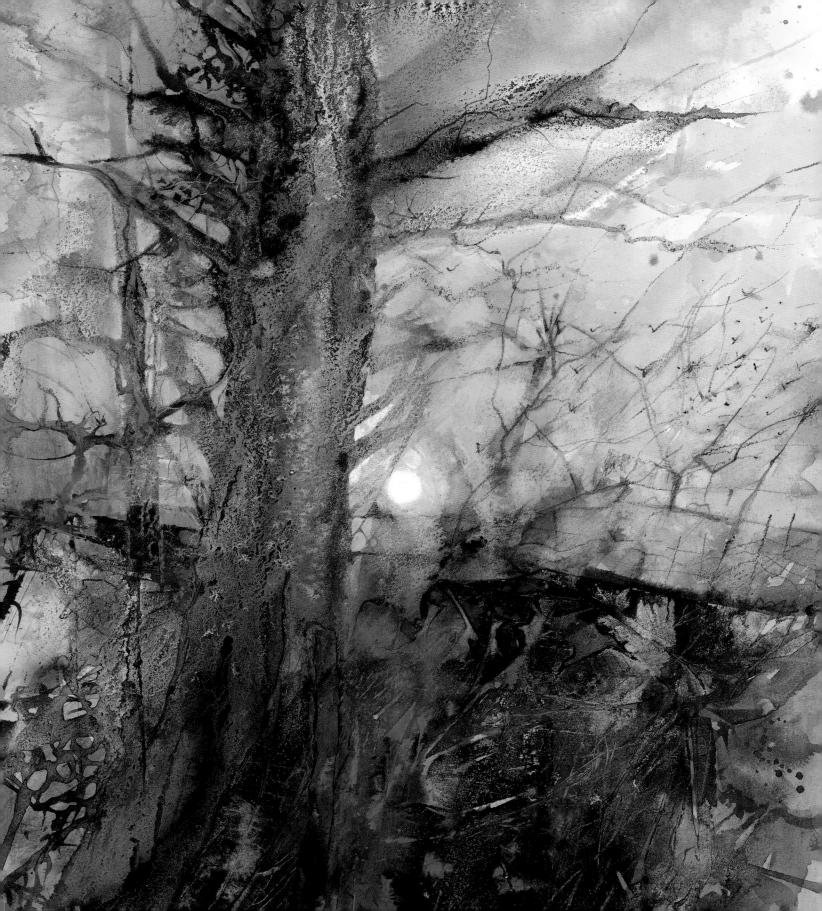

◀ Sundown and Home to Roost
46 x 35 cm (18 x 13³/₄ in.)

I played with many variations of colour before starting this painting, including those in *The Twilight Hour*. The main statement was the way the setting sun peeped from behind the tree, tinting the sky with a tangerine glow. I used clingfilm in the foreground and granulating textures and salt in the tree. The delicate marks of distant trees and crows flying home to roost were drawn in with a watercolour pencil, slightly distorting the perspective, to give it an air of abstraction. I painted the sun with white gouache over the top of my preliminary watercolour washes. My colour palette was Indian yellow, sepia and turquoise ink; French ultramarine, quinacridone gold and green gold watercolour and white gouache.

▶ The Twilight Hour
9 x 7 cm (3¹/₂ x 2³/₄ in.)

This miniature abstract painting began as a colour experiment for *Sundown and Home to Roost*. The larger version took on a life of its own and I used different colours in the end. However, I love the fact that this is jewel-like and decorative with an eerie, mystical quality. It was not planned as a finished painting, but I believe it warrants being treated as such and shall display it in a black box frame or with a disproportionately large mount to make it feel like a precious artefact. My colour palette was cobalt blue, quinacridone gold, light turquoise, quinacridone magenta and Indian yellow watercolour; white gouache; black ink and watercolour pencil.

Misty Hawthorn
34 x 50 cm (13$^{1/2}$ x 19$^{1/2}$ in.)

I paint this particular tree in all its seasonal guises. In spring it is covered in lacy blossom. In autumn it is reddened with berries and in winter the gnarled branches are revealed. In this version a mist transformed it, at least in my mind, to 'a mysterious tree from a folkloric tale'. I had written this in my notepad alongside a sketch describing the branch shapes and patterns of light. I chose materials and techniques to best represent this fantasy. A handmade paper with an uneven surface helped emphasize a granular wash. I used oil pastel to hint at lingering berries and rubbed silver paint into the lightest areas of the tree to add a magical element.

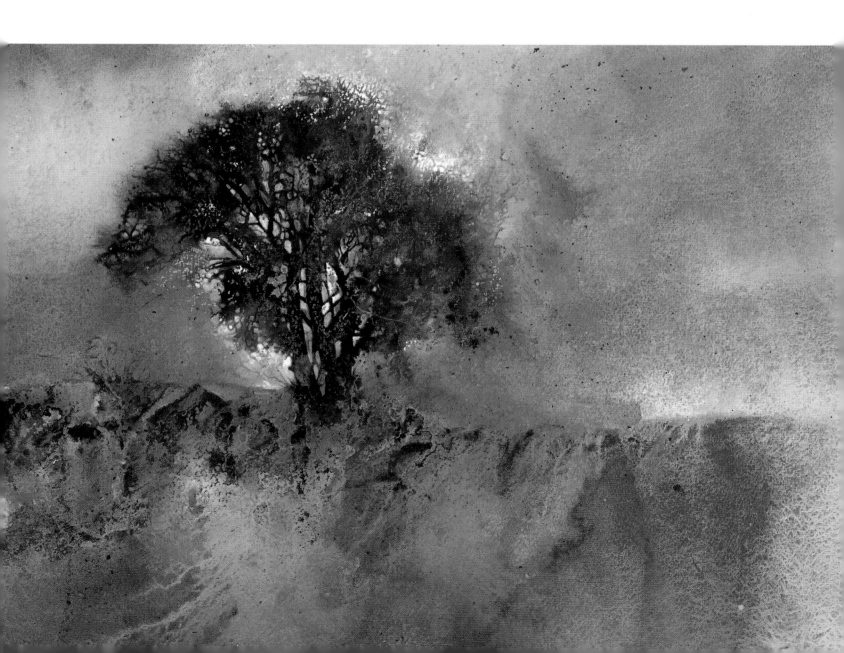

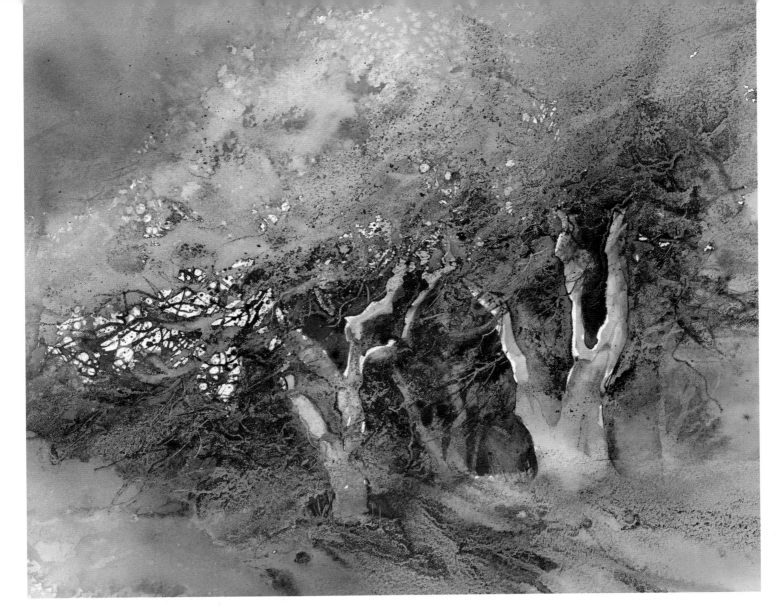

Beneath the Hawthorn Tree

28 x 31 cm (11 x 12¼ in.)

Seen in the cool hours of the morning, this thicket of hawthorns seemed to shimmer with dew. The shadowy interior was riddled with the earthy holes and burrows of badgers and rabbits. To interpret this, I painted the overall shape of the leafy tree as a cloud of watercolour and sprinkled on some salt to indicate the broken effect of the foliage. I dripped sepia ink into the varied washes and added granulation medium to break it into speckles. My colour palette was cobalt blue, French ultramarine and a little quinacridone gold watercolour.

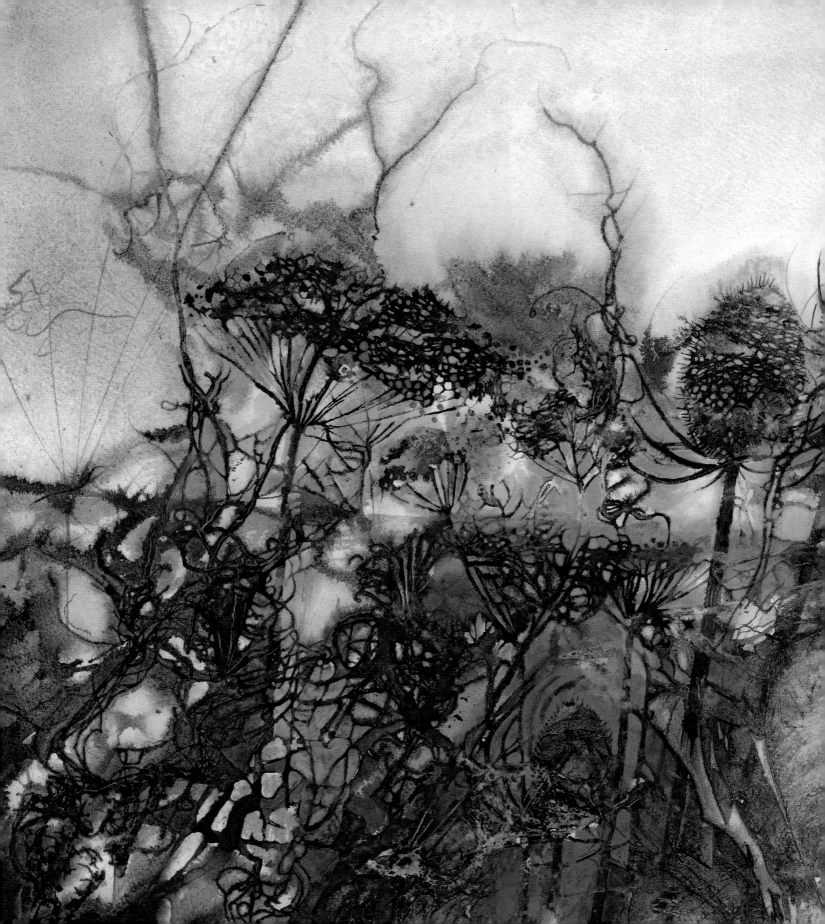

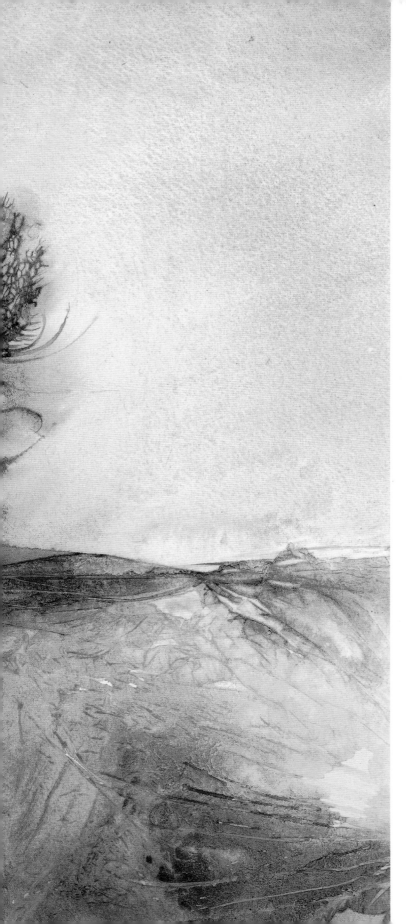

Flowers and nature in the landscape

Having painted flowers for most of my life, I felt that this book would not be complete without sharing with you some ideas for painting wild flowers in a landscape context. I have extended this to include other aspects of nature in the landscape, such as leaves, birds, butterflies and hidden creatures, clifftops and grassy banks, field edges with their fence posts and crumbling country walls. It is rewarding to paint the wider picture of skies and water, hills and moor, buildings and trees, but you can gather inspiration too from moving closer in to see beauty in the smaller-scale landscape details of hedge and wayside.

Teasel Tangles
37 x 44 cm (14^{1}/$_{2}$ x 17^{1}/$_{4}$ in.)

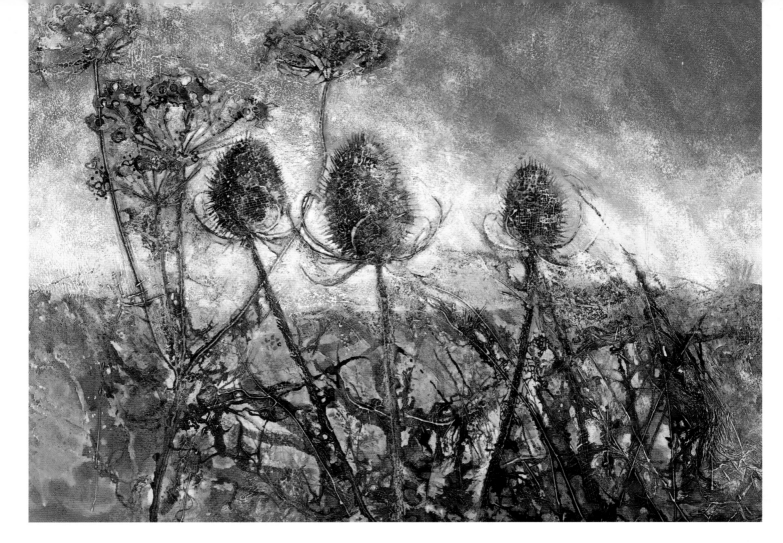

▲ Field's Edge
38 x 50 cm (15 x 19½ in.)

I love the weeds and seed heads of the
countryside, their textures and the way they
relate to their habitat. Some of my favourite
plants are hogweed and teasel, and it is fun to
experiment and search for new ways to interpret
them. In this version, I used scrim with gesso as
a shorthand for the teasels' textures and little
pieces of hole-punched watercolour paper to
represent the florets of hogweed seeds. I glued
down tissue paper using gesso to bring texture
to the ploughed field behind and used an icing
nozzle to 'draw' some grasses.

▶ Last Light
37 x 37 cm (14½ x 14½ in.)

When the sun is low and shines through the wild plants of the waysides
and hedges, it highlights their graphic silhouettes. This is an opportunity
to play with pattern whilst infusing the abstract design with the heady
romance of the scene. I used some tangled scrim to make imprints in
washes of watercolour and ink, also applying a limited amount of clingfilm
to the sky. Later, I painted paler, negative shapes of opaque colour to
bring out the shapes and patterns of the tangled plants. I chose a darker,
more textured area to develop the largest and most prominent teasel.

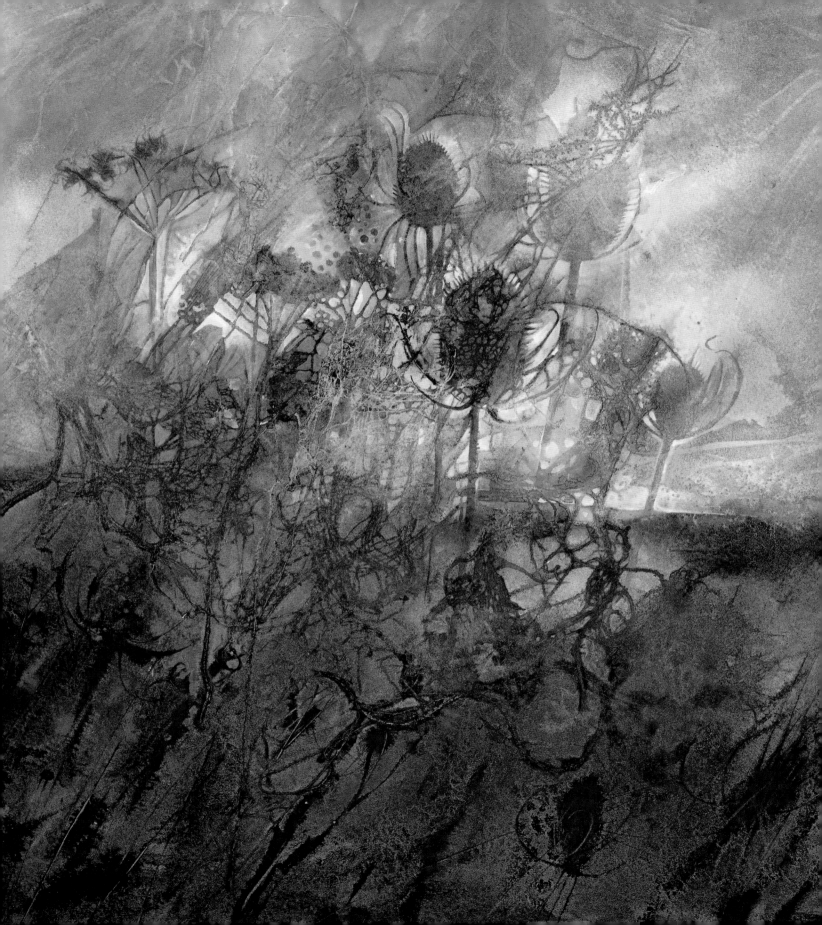

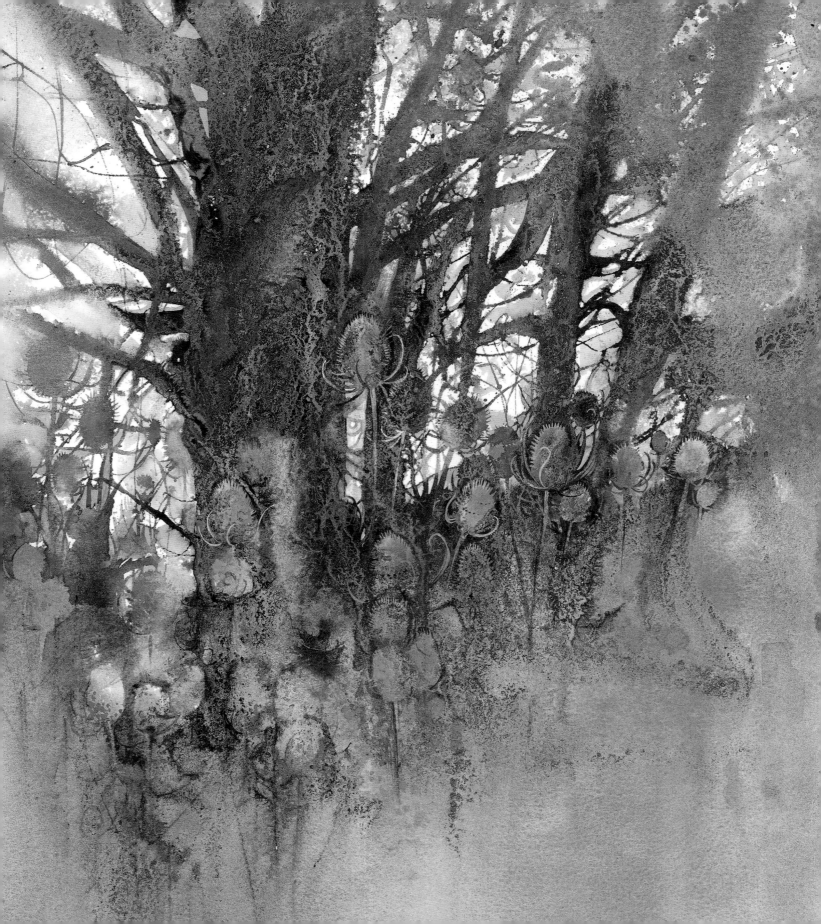

◄ Spring Teasels in the Wood
46 x 35 cm (18 x 13¾ in.)

When you are painting wild flowers in a
landscape it can be effective to use the
colour within the flowers as a wash around
them, creating the impression of quantity.
Individual plants or blooms can be developed
out of this background using positive or
negative paintwork. I have a favourite patch of
teasels down a wooded lane near my studio.
In the spring the teasels are speckled with a
glorious mauve, and I used cobalt blues and
violets in my painting to represent this. I
included a spring-like drift of green gold to
make these colours sing.

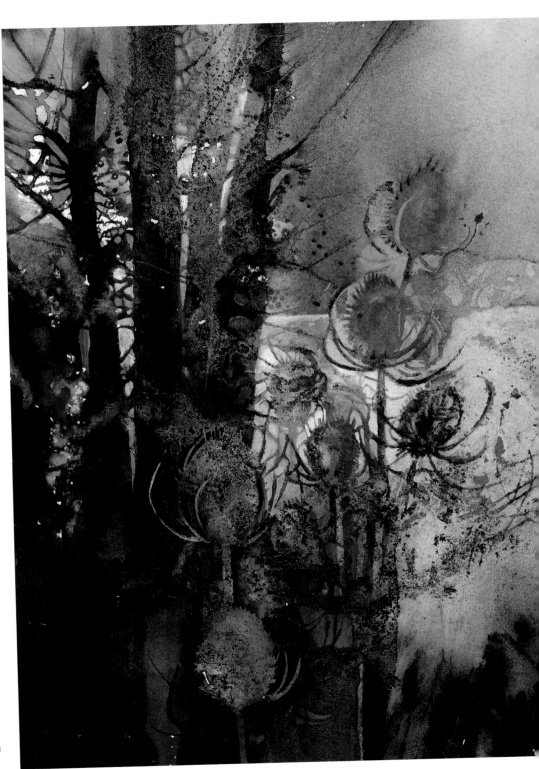

► Winter Teasels in the Wood
28 x 19 cm (11 x 7½ in.)

In winter the teasels are more dramatic and
their striking tendrils seem more pronounced.
I viewed their shapes against a frosted moonlit
field, adding them on top of a pale wash and
then emphasizing the shapes later with white
gouache. The darkness of the trees was
echoed by adding shavings of black and brown
Derwent Inktense sticks to the wet wash.

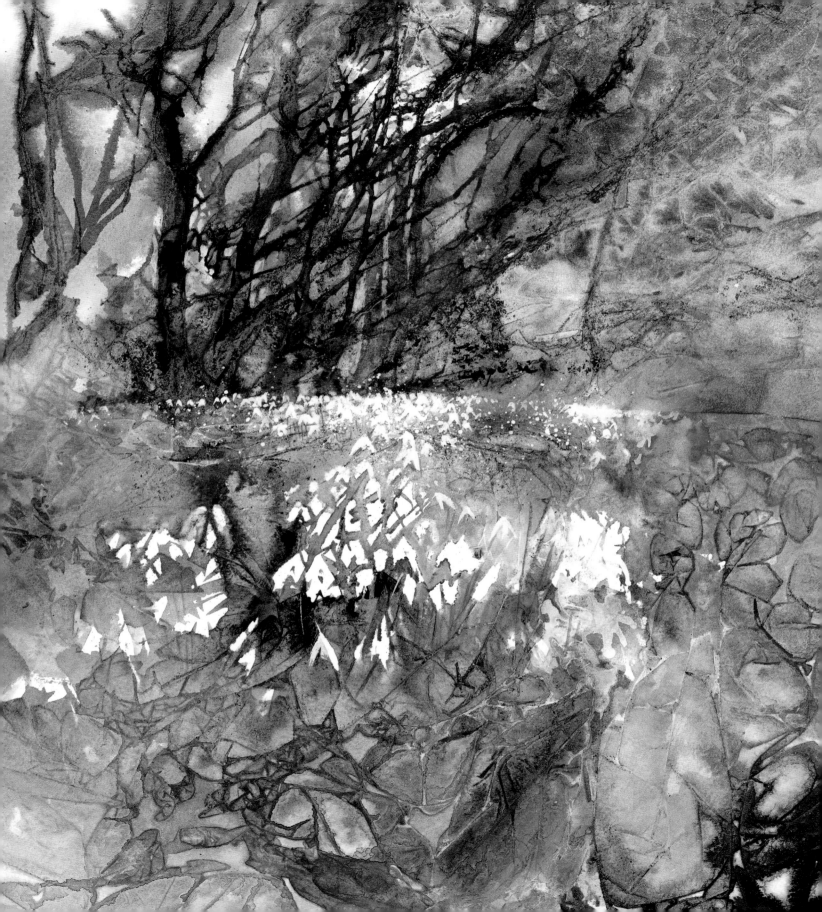

◄ Woodland Snowdrops
42 x 35 cm (16$^{1}/_{2}$ x 13$^{3}/_{4}$ in.)

Painted carpets of wild flowers can easily appear sentimental. To avoid this trap, I think about subjects in abstract terms rather than using the botanical information in my head. I *knew* that each of these snowdrops had shaded petals with leaves and a particular type of marking. What I could *see* was a pattern of crisp white snippets, which became smaller and softer as they receded. I looked for methods that would mimic these qualities. I suggested the more prominent snowdrops by using a flat brush to paint around hard-edged geometric shapes of white paper. I used a glaucous mix of cerulean blue and quinacridone gold, which echoed the colour of the snowdrops' leaves. The blur of distant flowers was smudged and spattered in using white gouache. I applied clingfilm scrunched tightly into small patterns, carefully dribbling sepia ink underneath to emphasize the markings.

▲ Summer Meadow
44 x 35 cm (17$^{1}/_{4}$ x 13$^{3}/_{4}$ in.)

This summer meadow was a medley of red campion and cow parsley. To suggest the abundance of flowers, I painted varied washes of quinacridone magenta, cobalt turquoise, French ultramarine and quinacridone gold. A sprinkling of salt made tiny florets of texture that hinted at small flowers and a haze of cow parsley. I picked out a few petals with negative painting from within the pink wash, which was sufficient to imply a whole carpet of flowers. I fragmented some pieces of white Japanese lace paper and stuck these on to describe foreground cow parsley, using strips of the paper for stalks. I tinted these with dilute colour to integrate them with the painting and splattered white gouache to suggest more lacy effects.

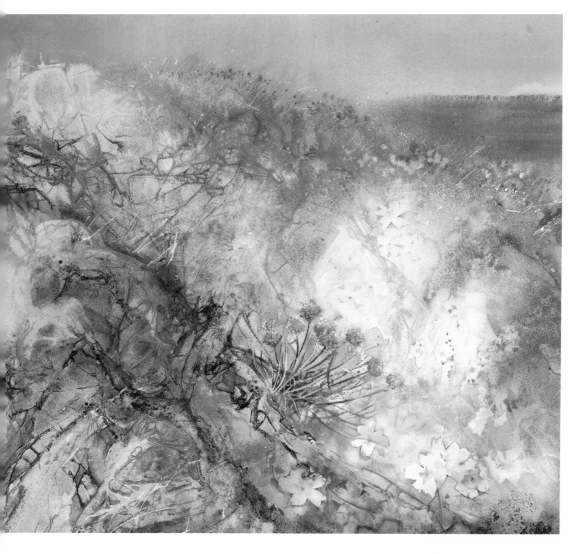

▶ Primrose Bank
40 x 36 cm (15³/₄ x 14 in.)

A coastal walk along clifftops studded with primroses and sea pinks fed my imagination for a whole series of pictures. In this version, I used masking fluid to block out the small shapes of primroses. This gave me the freedom to let washes of colour flow down the page. I used French ultramarine, quinacridone gold and green gold watercolour to describe the springy turf and added sepia ink broken through with granulation medium to suggest earthy crevices. A touch of cobalt violet hinted at some sea pinks. The rough fence of scrub and sticks was painted using a rigger brush and watercolour pencil.

▲ Coastal Walk
43 x 43 cm (17 x 17 in.)

The clifftops were a kaleidoscopic riot of yellows, orange and pink; I developed this area with clingfilm textures to set the scene. There was a cloudless sky and the sea below was a picture book blue – I painted these with simple washes to contrast with the complex patterns of the wild flower carpet. Individual primroses were pulled out of the background using negative painting, but the sea pinks were added on top using darker paint and touches of oil pastel. The fringe of smaller flowers along the cliff's edge was dotted in with soft pastels.

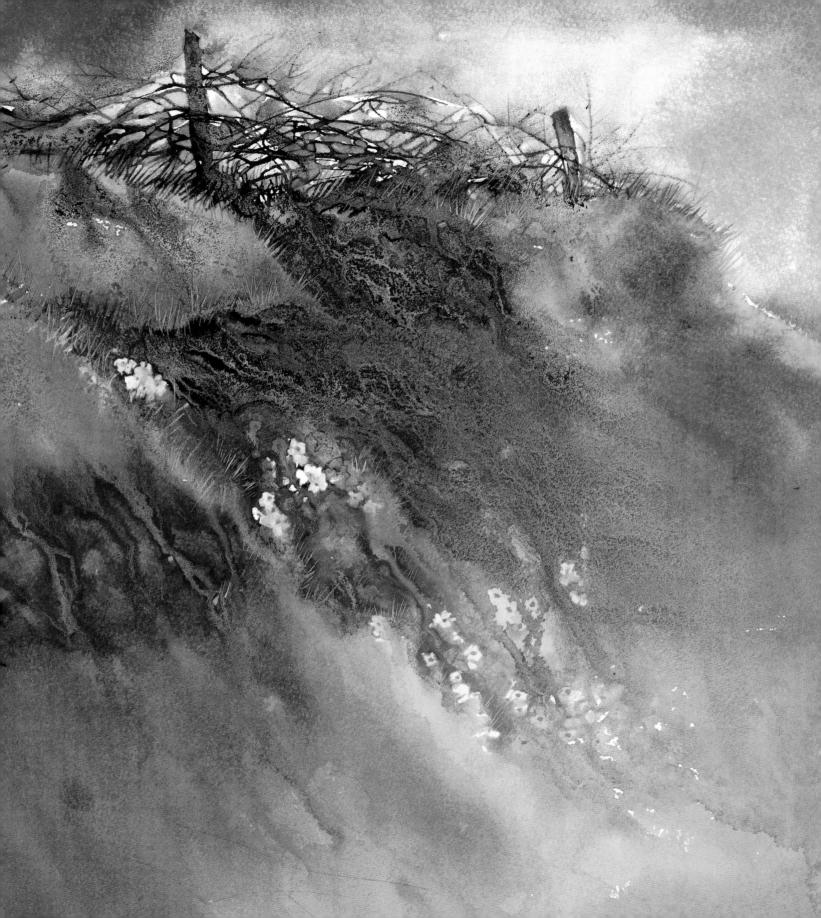

Water Lily Pond

30 x 46 cm (12 x 18 in.)

A single flower shone out from the dark backdrop of water lily leaves on the shadowed pond. The huge oval and circular leaves overlapped to create wonderful patterns, which echoed the rounded rocks at the pond's edge. I decided to experiment with an unusual technique to create an abstract interpretation of the view. I masked out the water lily first to preserve its crisp whiteness. Working with my paper on a board, I made washes and stretched some sheer fabric tightly over it, ripping and creating holes through the threads. I pinned this down at the sides to keep it in place and soaked it with more colour. This formed fabulous patterns and rounded markings as the paint dried. The white marks are where there was less paint in the fabric and the paper stayed unmarked.

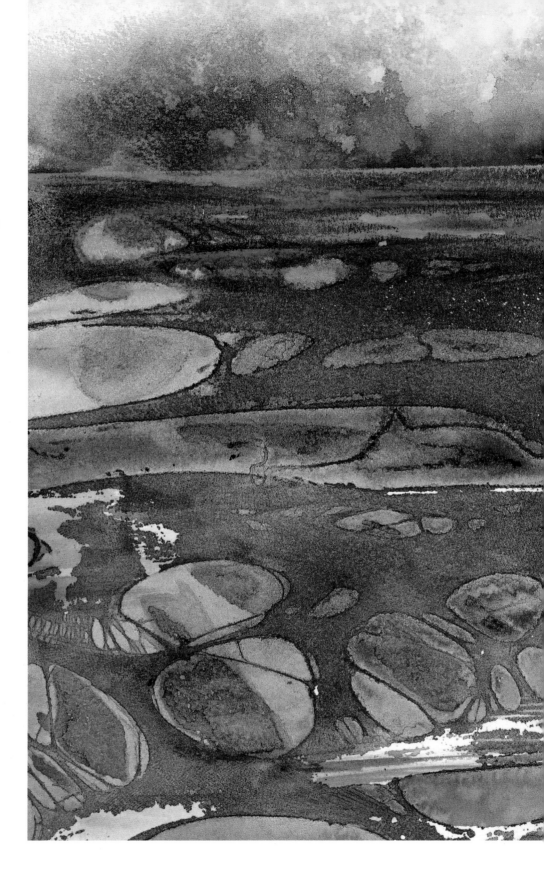

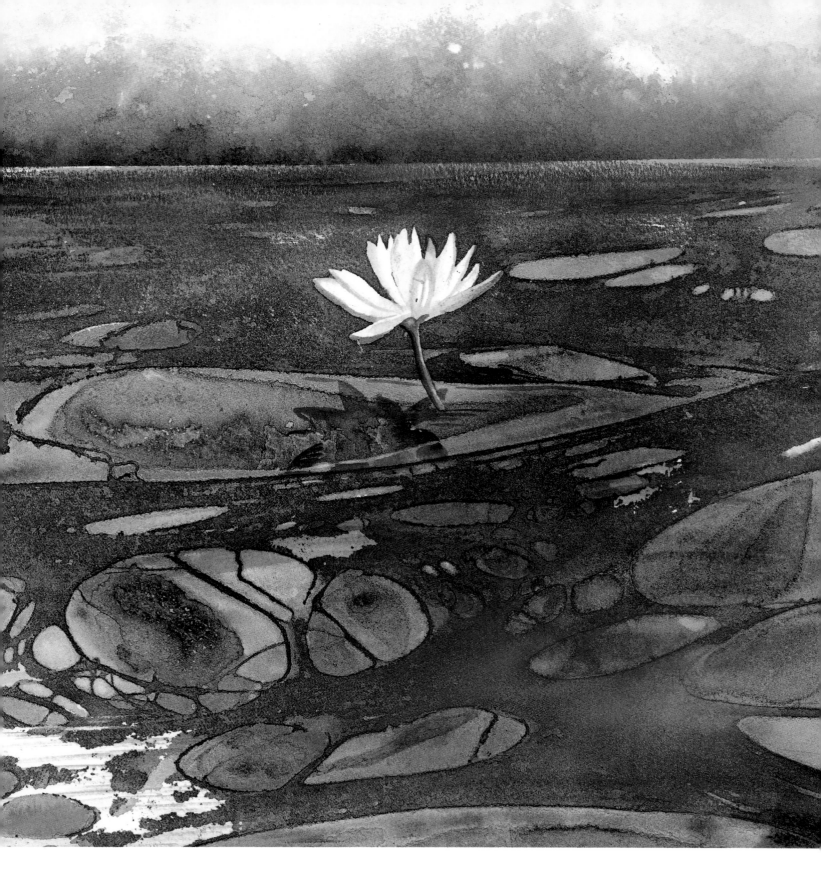

▶ Foxglove Fantasia
52 x 52 cm (20¹/₂ x 20¹/₂ in.)

In this interpretation of foxgloves growing amongst swaying grasses, I developed the flowers out of the background. In my initial wash I established an area of pink where I wanted them to grow, then built up layers of texture over all the paper using clingfilm to create a batik-like effect. Pale gouache was used later to suggest the edge of the field, and paint around the foxglove shapes to conjure them out of the backdrop.

◀ Foxglove Textures
54 x 57 cm (21¹/₄ x 22¹/₂ in.)

In a second version of the foxglove field, I painted on paper that had been partially covered with gesso. I used an icing nozzle to dribble and squiggle some lines of gesso over the first layer to loosely draw the bell shapes of the foxglove, adding linear marks for grasses. The paint reacted on the varied surface in different ways to make interesting, organic-looking textures.

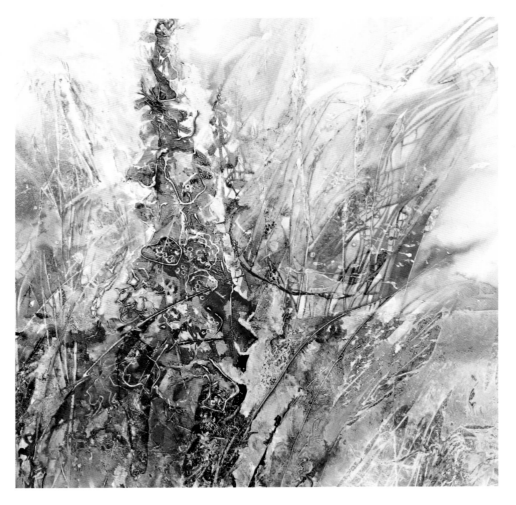

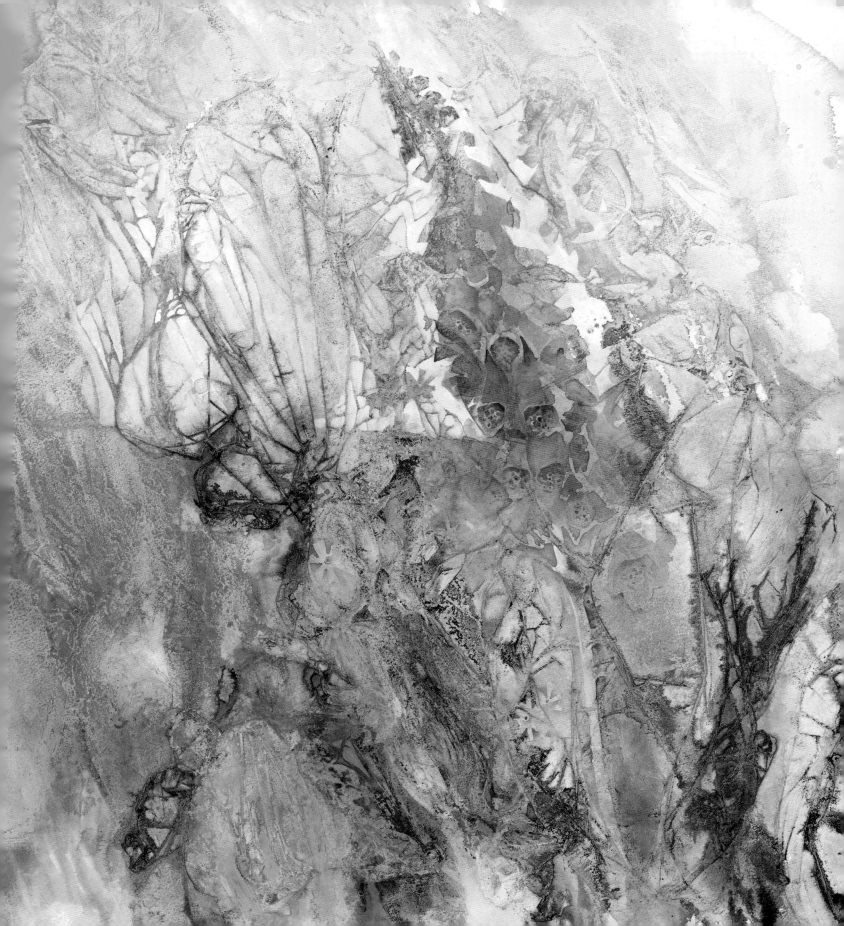

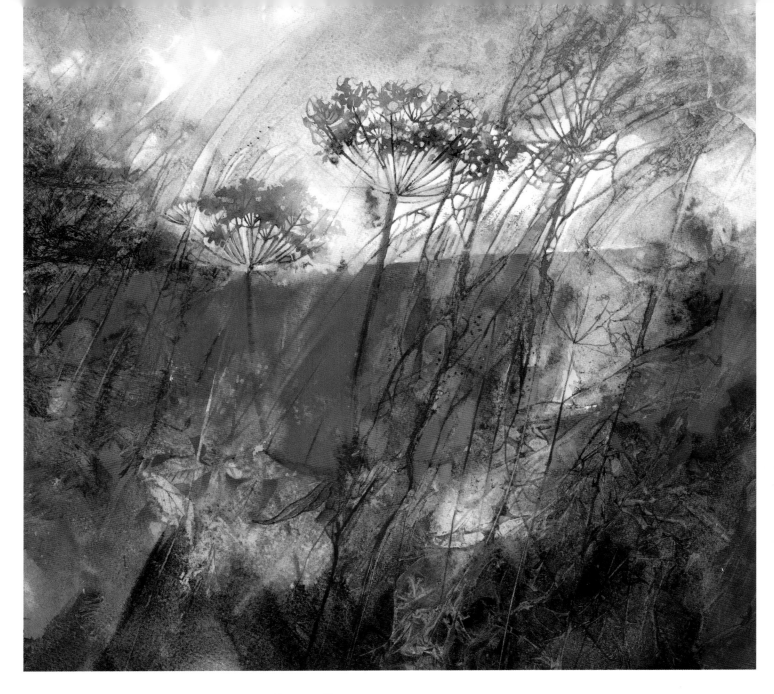

Poppy Pasture
36 x 38 cm (14 x 15 in.)
I viewed this red pasture through the fronds of weeds and herbage of a grassy verge. The scarlet of the poppies glowed through the stripes of stalk and stem like the light in a stained-glass window. In my painting, I allowed each colour to stray from one area into the next. I placed loosely crumpled clingfilm over the lower washes to create abstract leafy markings and stretched clingfilm to form a linear effect and create grassy marks further up. I painted white gouache over part of the sky, scraping through it with my palette knife to reveal lines of darker colour underneath in the shape of grasses and hogweed. I extended and added to these linear marks with watercolour pencils.

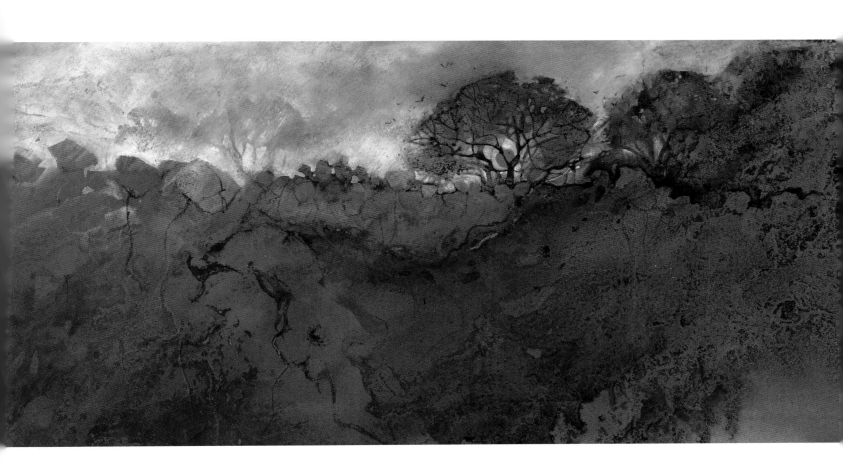

Red Meadow, Scarlet Moon
20 x 33 cm (8 x 13 in.)

I developed this painting from an experiment in which I had used black Indian ink with red watercolour. The colour combination suggested a poppy field, so I used watercolour pencils to indicate flower centres, stems and trees. I used white pastel over the sky to cover up most of the red, but let some shine through. A Conté pencil was useful for the more detailed gaps between branches and around the scarlet moon, which was originally part of the background.

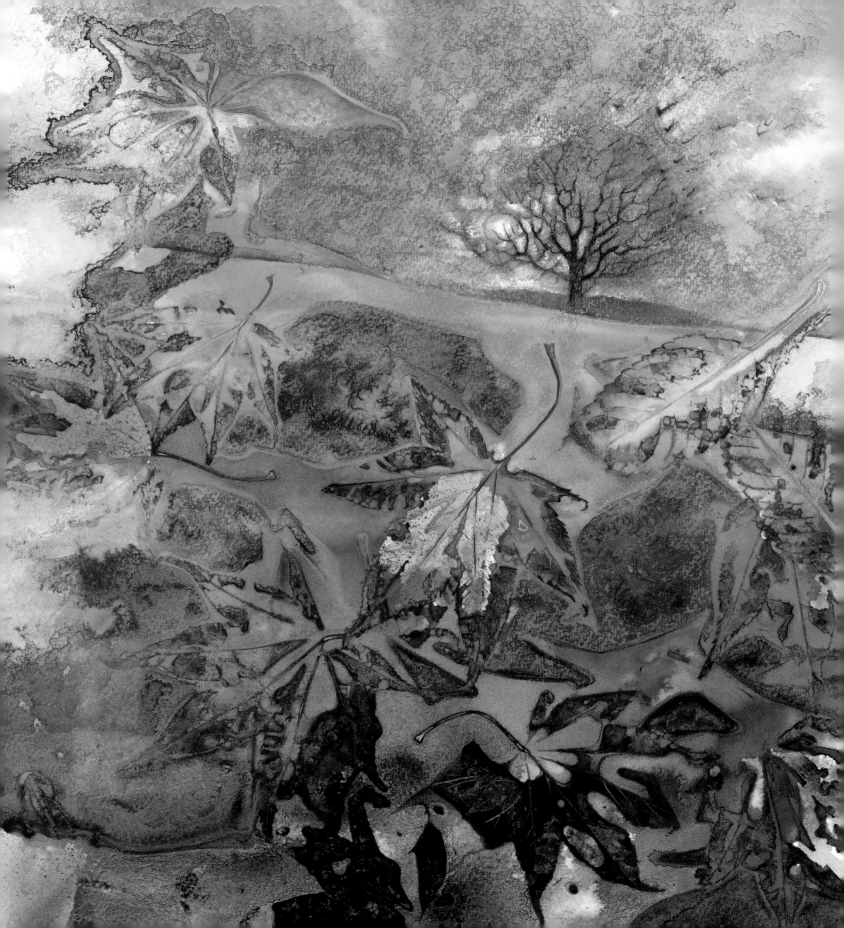

◀ Catch a Falling Leaf
38 x 32 cm (15 x 12¹/₂ in.)

This quirky painting was developed out of printed impressions made from maple leaves. I positioned the leaves over a wash, added further ink on top and placed cellophane over it until dry. A fantastic and unexpected abstract design emerged from this, to which I added a tree on the horizon. This created the idea that the leaves were blown off the tree into an oriental carpet of colour. Inks used included raw and burnt sienna, yellow ochre, sepia, a little quinacridone magenta and that fabulous splash of turquoise.

▶ From Small Acorns
29 x 28 cm (11¹/₂ x 11 in.)

I made further impressions from leaves found under an old oak tree. I used fewer leaves than in the painting opposite, but still covered the whole picture with cellophane. The plastic pressed the wash of ink and watercolour with which I had covered the paper into an intricate texture. I painted an oak tree over these marbled markings with brown and gold ink. The jigsaw shapes of the oak leaves gave me the idea of tearing sections of the painting into pieces and reassembling them like a jigsaw. As a finishing touch, I added a golden acorn.

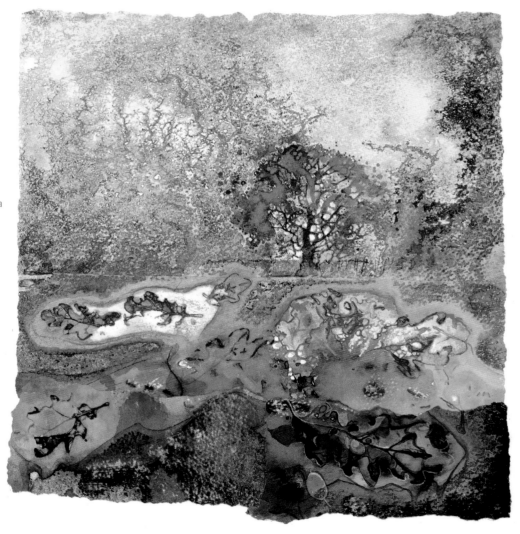

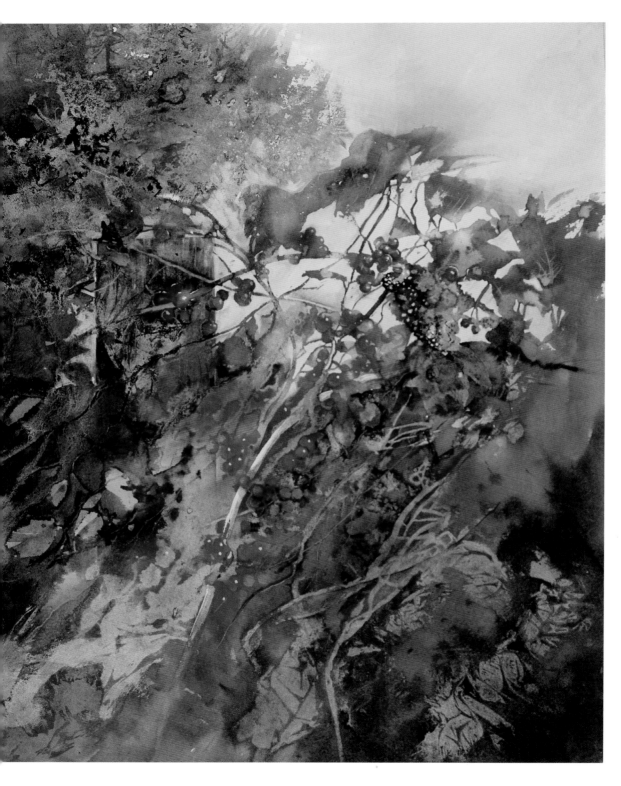

Autumn Hedgerow
46 x 36 cm (18 x 14 in.)

It may seem odd to be obsessed by English hedgerows, but I am passionate about them. They contain a huge variety of plant forms, tangled together and embroidering rich tapestries of colour. The hedge is a constantly changing abstract pattern and of course is a special joy in autumn when festooned and bejewelled with berries. The intricate weavings of texture can easily create a fussy composition but the straight lines of a post, gate or fence add a firm geometric anchor on which to hang the design. In this version I also used a diagonal trail of bright crimson bryony berries to draw the eye through the picture.

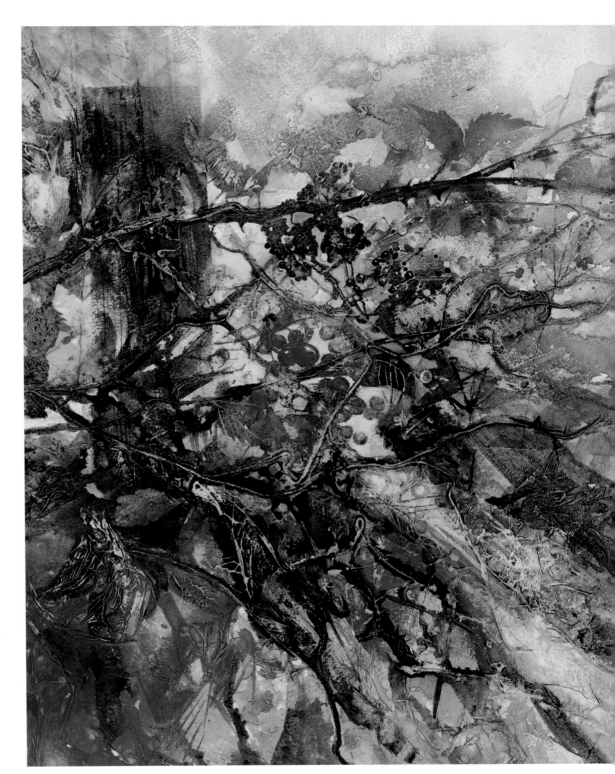

Hedgerow Corner

37 x 31 cm (14^{1}/$_{2}$ x 12^{1}/$_{4}$ in.)
This is exactly the same hedge
corner as in the painting opposite.
However, in this interpretation I
painted on top of a surface largely
covered with gesso and tissue
paper, coaxing the thin tissue into
stem-like ridges or shapes that
suggested leaves. I painted the
fence post in one-third of the
design but placed some red berries
in an almost central position to
ensure that these were the focal
point and not the larger brown
post. I intensified the red so that
the berries became a really eye-
catching feature in a composition
of mainly small shapes.

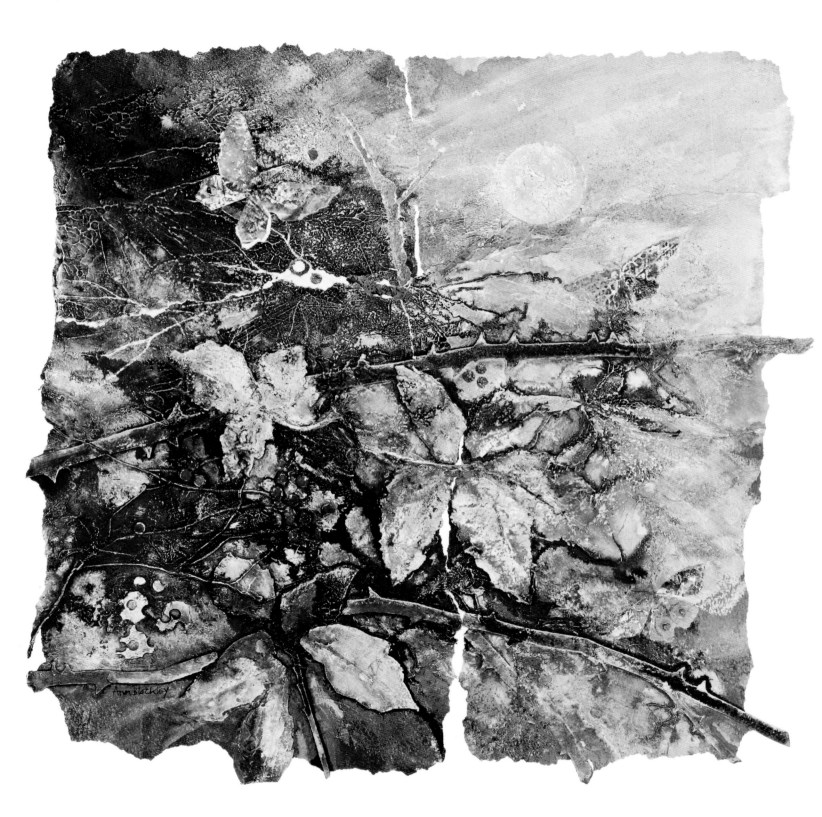

◀ Moths and Moonshine
42 x 42 cm (16½ x 16½ in.)

I developed this collage over a period of time, adding and subtracting pieces until I was satisfied. It began as a painting of brambles made on a collage of watercolour paper shapes. I decided it did not work, ripped it up in anger and threw it in the bin. Glancing at the pieces later, I suddenly saw what I could do. This time I tore parts of it away thoughtfully and reassembled the sections on fresh white paper. I made moths' wings out of the discarded pieces and stuck these on the collage. They mimicked the leaf shapes as if they were camouflaged. The top right-hand corner of the picture was still unbalanced, so I added an iridescent moon.

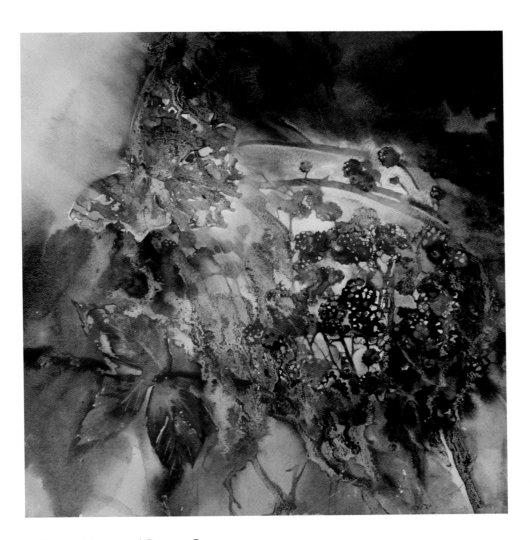

▲ Brambles and Butterflies
36 x 36 cm (14 x 14 in.)

Landscapes are populated with creatures, insects and birds and the addition of wildlife to a picture, even as a speck in the distance, can really make it come alive. I am especially drawn to moths and butterflies, having spent many years as a flower painter. I see them as moving versions of flowers, with wings rather than petals and antennae instead of stamens! In this butterfly-inhabited hedge I painted washes of colour and dribbled granulation medium through certain areas to create textures that echoed those in the wings. I gave the butterfly movement by dampening and softening parts of the wings' edges into the background wash.

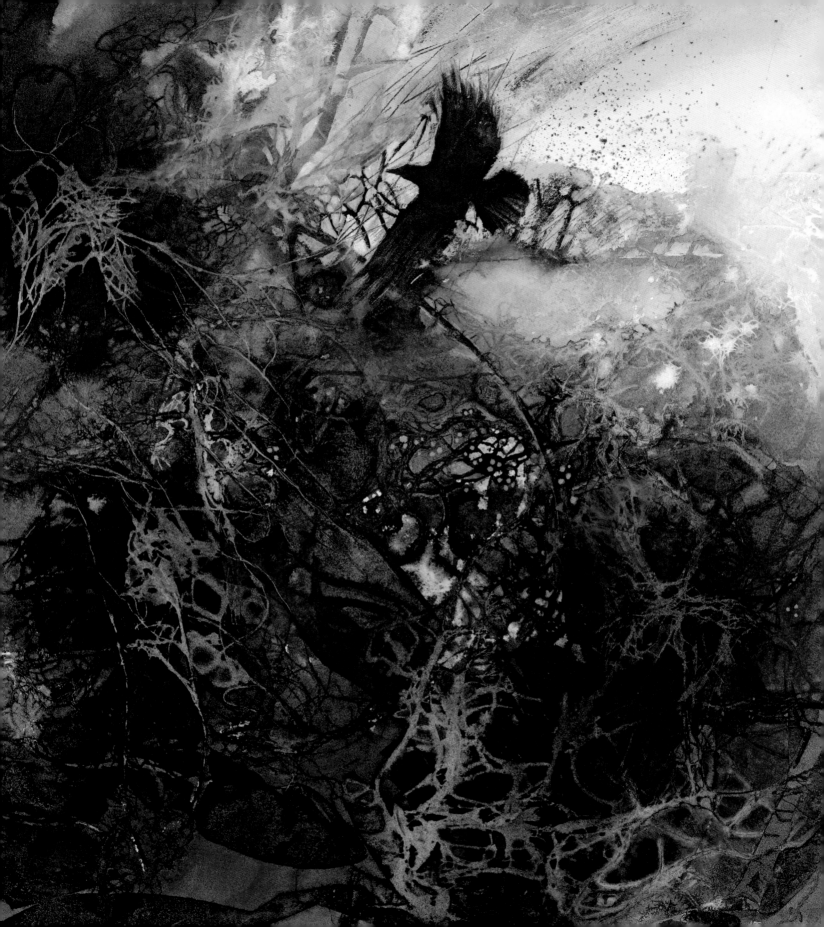

◀ A Bird in the Bush
34 x 35 cm (13^1/$_2$ x 13^3/$_4$ in.)

I created a watercolour pattern using imprints of threads and fabric. It suggested the tangles and brambles of a hedgerow. Towards the top there was a dark patch of ink, which dominated the composition. I reshaped it using pale gouache and created a flying bird, scraping through the gouache with a knife to reveal dark, branch-like marks.

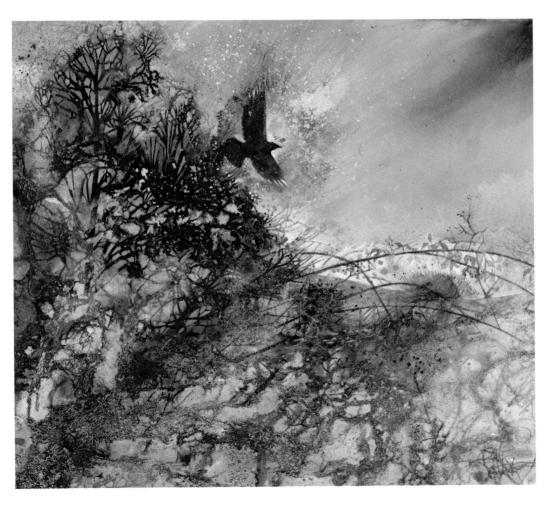

◀ Over the Bramble Patch
34 x 35 cm (13^1/$_2$ x 13^3/$_4$ in.)

I went through a phase of painting birds this autumn. They seemed to be everywhere I looked, and I made a series of pictures. This interpretation involved more textural effects. These were quite random, so I added structure with the arching stems of a bramble and indicated a glimpse of the distant field. I spattered dots of colour around the bird to suggest movement and balanced this dark shape with a shadowy cloud in the corner of the sky.

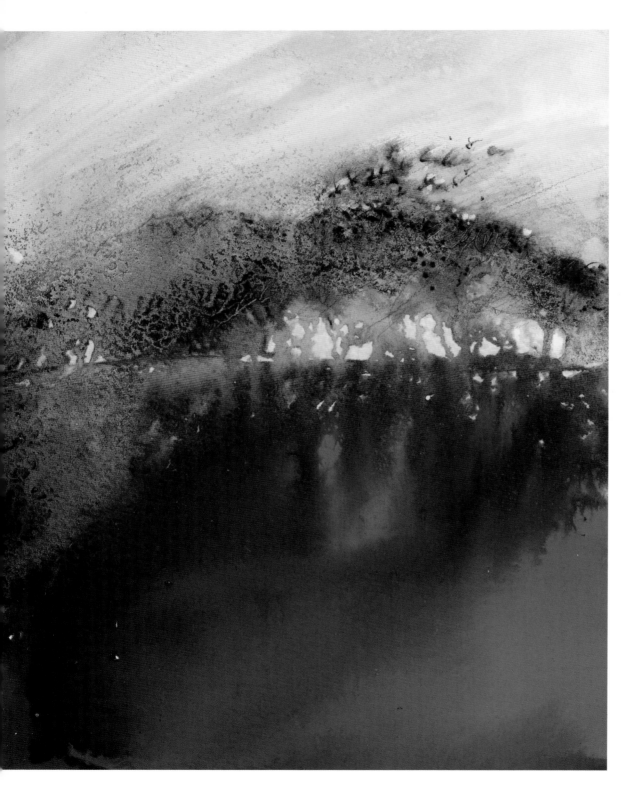

Son et Lumière
23 x 18 cm (9 x 7 in.)

Every evening as the sun descends, the rooks fly across the distant trees searching for a place to roost. They swirl and screech, descending and reascending. The light grows brighter as the sun sinks and the noise reaches an incredible crescendo. I often watch and listen to this theatrical ritual and it is a subject I love to paint. In this small, semi-abstract experiment I used Daler Rowney FW artists' acrylic inks. It was only a quick 'play', but it captures something of the electric atmosphere as the sky reached its brightest moment. It does not 'look' like the scene as it actually appeared, but it does express something of the moment.

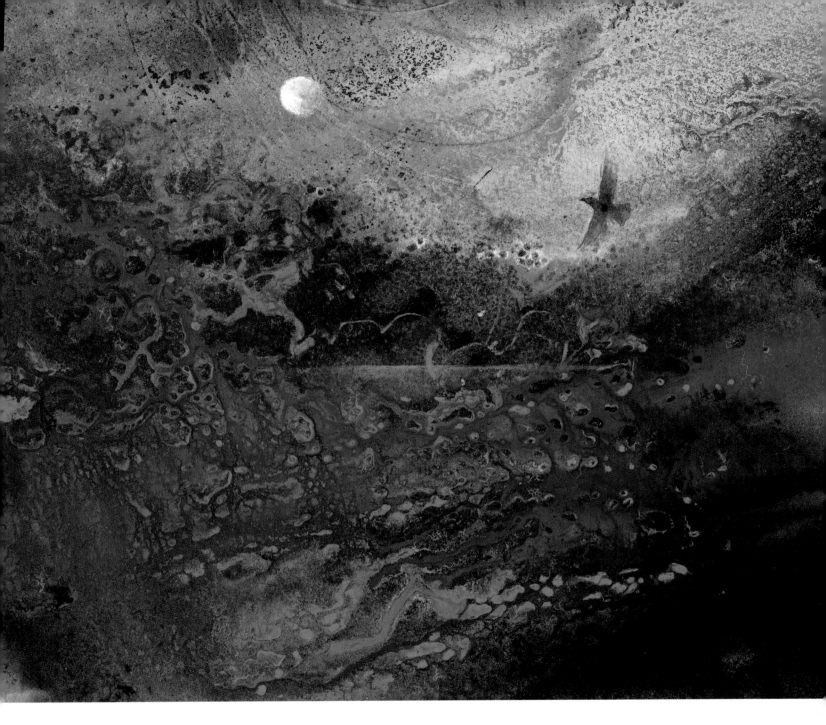

Flying to the Moon
17 x 19 cm (6³/₄ x 7¹/₂ in.)
This little piece was painted for you: I want you to feel that through your art you could fly to the moon if you want to enough! I have loved making the paintings for this book and sharing my ideas with you. I hope you will now experiment with some of the techniques in the first chapters and take inspiration from the thoughts and ideas in my paintings. It is now time for you to put all this together and create your own beautiful pictures that are special to you, to feed your soul and make you feel that anything is possible.

Index